*The Campus History Series*

# GEORGIAN COURT
# UNIVERSITY

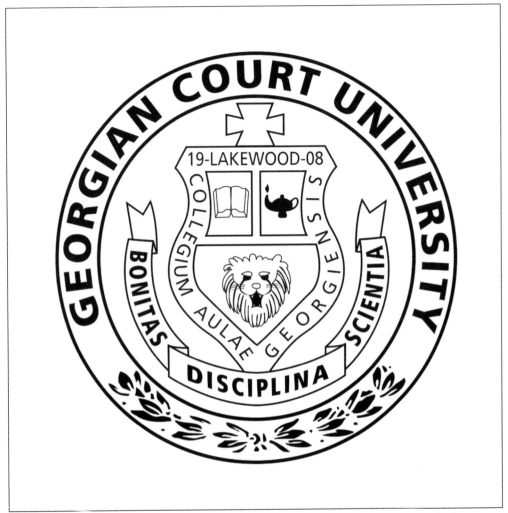

The seal of Georgian Court University features the cross of Christ, which symbolizes true Christian character. This character is enlightened by the lighted lamp and illustrates the virtues of truth and goodness. These virtues are fostered through the book of the arts and sciences by which Courtiers achieve intellectual development. The lion signifies moral and physical fortitude united by the laurel wreath, the Greek symbol of victory and triumph. The name of the school is inscribed in English and Latin, accompanied by the founding date, 1908, and the location, Lakewood. The Latin words *Bonitas, Disciplina, Scientia*—goodness, discipline, and knowledge—that appear at the bottom of the seal are the virtues through which the Georgian Court graduate will triumph in the formation of her or his character.

*On the cover*: Completed in 1898, the Georgian-style Mansion once home to the Gould family remains a focal point of the Georgian Court University campus. Furnished with many original antiques, the Gilded Age glory of the Mansion is a welcome respite for both the community and the public for a variety of events. (Courtesy of Georgian Court University Archives.)

*The Campus History Series*

# GEORGIAN COURT UNIVERSITY

EDWARDA BARRY, RSM, PH.D.

ARCADIA
PUBLISHING

Published by Arcadia Publishing
Charleston SC, Chicago IL, Portsmouth NH, San Francisco CA

Printed in the United States of America

Library of Congress Catalog Card Number: 2006935918

For all general information contact Arcadia Publishing at:
Telephone 843-853-2070
Fax 843-853-0044
E-mail sales@arcadiapublishing.com
For customer service and orders:
Toll-Free 1-888-313-2665

Visit us on the Internet at www.arcadiapublishing.com

*This book is dedicated to the future members of the Georgian Court University community. You, dear friends, are the beneficiaries of a legacy created for you by the women and men associated with the Court during the past 100 years. Your inheritance is a rich tapestry of academic achievement, service, spiritual growth, and personal development. Future chapters of the history are yours to write as you participate in and support the various academic and social programs of the university. May the contents of this book be a source of pride in your legacy, the treasured history of Georgian Court University.*

# CONTENTS

# ACKNOWLEDGMENTS

Many members of the Georgian Court University community contributed to the completion of this book. I am especially grateful to Ruth Ann Burns, vice president for marketing and external affairs, and her dedicated staff, including Deborah Gilleran, Tara Strickland, Kathleen Guilfoyle, Elizabeth Brennan, Sister Francesca Holly, and Vera Towle. I am also grateful to Sister Barbara Williams, university archivist; June Cottrell-Miller, archives secretary; Sister Elizabeth O'Hara, Sisters of Mercy archivist; Cynthia Lisowski; Mary Cranwell; Claribel Young; and other faculty and alumni who assisted with the identification of vintage photographs. Thank you to all the friends who supported this project with research and prayer.

# INTRODUCTION

Georgian Court University celebrates the 100th anniversary of its founding in the year 2008. Through 10 decades the vision of the Sisters of Mercy and the Mercy values of integrity, respect, compassion, justice, and service have created an impressive tapestry weaving together the past, present, and future of Mercy higher education in New Jersey.

The university campus in Lakewood and alternative sites throughout the state are alive with the same display of youthful enthusiasm and energetic activity that, according to tradition, marked the 1908 opening of the college in Plainfield under the title of Mount St. Mary's College and Academy for Young Ladies.

Founders and present-day sponsors of Mount St. Mary's College and Academy, now known as Georgian Court University, are the Sisters of Mercy, a religious congregation of Roman Catholic women. From 1908 to the present, eight Sisters of Mercy have served the school as president. Approximately 114 Sisters of Mercy have held administrative, faculty, and staff positions. Today 25 Sisters of Mercy serve Georgian Court University as administrators, faculty, and staff.

As a Catholic community of women religious, the Sisters of Mercy share a ministerial relationship with the Catholic Church. From its beginnings Georgian Court has experienced the affirmation of diocesan church officials. In turn, it has enhanced the educational ministry of the Catholic Church by hosting church-related programs, by educating teachers for both parochial and public schools, and by preparing lay ministers in service to the church.

The inspiration of Catherine McAuley (1778–1841), founder of the Sisters of Mercy, is alive not only in the Sisters of Mercy, but also in the hundreds of faculty and staff who have served in true Mercy tradition for these 100 years.

McAuley was a young Irish lady who chose to devote her energies to improving the plight of the poor in 19th-century Ireland. In 1827, she used a large inheritance to commission the construction of a residence for poor working girls and situated the building on Baggot Street, a fashionable residential area in Dublin. McAuley wanted the homeless and the poor women cared for in her House of Mercy to be visible to the wealthy. With the women who joined her, McAuley taught young Irish women dressmaking, handcrafts, and other skills with which they might support themselves and contribute to the support of their families.

An accomplished educator, McAuley bequeathed to her followers a legacy of warm hospitality, collaboration with the laity, a deep concern for the poor, a firm commitment to the education of women, and an informed response to the needs of the time. Upholding this legacy, many Sisters of Mercy left Ireland for America to care for the education, physical welfare, and religious instruction of the Irish families who had emigrated there in the late 19th century. They arrived at a time when American society was coping with conflicting and competing ideas impacting the education of women.

Nineteenth-century images of the ideal woman presented her as cultured, familiar with the arts, suited for marriage, and a model of domesticity. She was not expected to be interested in or knowledgeable about the social issues of the day.

Economic developments in America, as well as a growing appreciation of the intellect of women and their potential contribution to society beyond the home, began to modify the traditional image at the beginning of the 20th century. A new sensitivity to the equality of the sexes was creating a broader openness to higher education for women and a rethinking of the subject matter to which they should be exposed.

In another arena of change, leaders of an immigrant church in America, concerned about potential challenges to the Catholic faith presented by professors in the existing secular and sectarian colleges and universities, discouraged Catholic women from attending these institutions. Aware of their responsibility to provide alternatives for the education of women, American bishops turned to the religious communities of women to open colleges for women of all faiths, in particular for young Catholic women.

At the request of Rt. Rev. Bishop James A. McFaul, bishop of Trenton, a group of Sisters of Mercy in Bordentown, New Jersey, accepted responsibility for founding a college for young ladies. Choice of a location for their new venture was simplified by the generosity of friends David and Catherine Kenney.

The Kenneys, whose daughter had been taught by Sisters of Mercy in Plainfield, were owners of a large tract of land in the Watchung Mountains of Plainfield. They donated 30 acres of the land to the Sisters of Mercy in gratitude for their kindness to their daughter.

Plainfield was, at the time, a city of great promise, located on a main railroad line that offered convenient access both to New York and Pennsylvania. The Sisters of Mercy began to envision their new school in this beautiful mountainous setting, located on major roadways and not far from New York City.

The daunting project began on December 8, 1905, when, in the presence of legal witnesses, three leaders of the Sisters of Mercy community signed an act of incorporation empowering the Sisters of Mercy to found and conduct a college for women.

Mother Mary Gabriel Redican, reverend mother of the Bordentown community of the Sisters of Mercy, broke ground on July 16, 1906, and, nearly one year later, Bishop McFaul laid the cornerstone of Mount St. Mary's College and Academy. In 1908, a three-story residence and classroom building was completed. Bishop McFaul proclaimed the dawn of a new era in the history of Catholic education.

Mount St. Mary's College and Academy opened on September 24, 1908. The enrollment of seven young women included Alice Irene Jaccard from France, Loretta Nolan from Trenton, Irene Duchesne from North Plainfield, and four Sisters of Mercy—Mary John Considine, Mary Mercedes Rodgers, Marie Anna Callahan, and Mary Bertrand Miller. All seven members of the class graduated four years later in 1912, establishing an astonishing retention rate of 100 percent!

College officials announced to the public the aims of Mount St. Mary's College: to give to young women a well-balanced education, along physical, intellectual, and moral lines; to fit students for any sphere of life; to prepare students to enter vocational fields adapted to their talents, including domestic science; and to train them in social graces essential to all leading women.

These early aims of Mount St. Mary's College, later referred to as the mission, changed over time to reflect social roles and student needs. They are the thread that weaves through what we have referred to as a wonderful tapestry—the past, present, and future of Mount St. Mary's College/Georgian Court College (now a university).

Throughout its history Georgian Court has had an enduring commitment to a values-based liberal arts education; the preparation of students who will make a contribution to their society and the Catholic Church; the development of the leadership talents of women; and to the cultural, social, and spiritual growth of the entire campus community.

Today Georgian Court University is a thriving university providing a comprehensive liberal arts education in the Roman Catholic tradition. Through the Women's College and the coeducational University College, Georgian Court offers more than 3,000 students

a curriculum and environment that enables them to grow through shared educational, cultural, and spiritual experiences.

In six chapters, arranged in chronological sequence, this book recalls the values, interests, activities, academic growth, student fads, and accomplishments of members of the college/university community, as well as the social settings of the times. Each of the six chapters is introduced with a quotation found in McAuley's letters and instructions, and by a brief summary introduction to the chapter.

Chapter 1 covers 1908 to 1923. Mount St. Mary's College was established 12 years before the passage of the 19th Amendment, which gave women the right to vote. While the United States was evolving as a world power and becoming the most industrialized nation in the world, students at the fledgling college in Plainfield were concerned with the peace efforts following World War I and the problems of new European immigrants.

The move to Lakewood covered in chapter 2 was the start of a growth spurt for the college as it made the majestic George Jay Gould estate its own by becoming Georgian Court College. From 1924 to 1944, against the backdrop of the Great Depression, World War II, and the rise of women in the workforce, Georgian Court College students put the Mercy values to work in and out of the classroom.

Both Georgian Court College and the United States experienced rapid change and growth from 1945 to 1965, the time period covered by chapter 3. It was an era of excitement and prosperity. International students came to the Court from China, Japan, and the Philippines. Student activities featured the Equestrian Club and the highly popular sport of golf. The campus landscape was changing also with the construction of a library, a student residence hall, and a dedicated classroom building.

Chapter 4 covers the tumultuous time period of 1966 to 1986. The Georgian Court of this era reflected world and national events from the battlefields of Vietnam to the Haight-Ashbury district. New student organizations formed, student focus was on social justice and peace movements, and the college invited students to follow Mother McAuley's example by contributing to positive changes in their college and the world.

Change continues in the years covered by chapter 5—1987 to 1999. The role of women was again in the headlines: Sandra Day O'Connor became the first female Supreme Court justice, and Sally Ride became the first American woman to orbit Earth. NASA chose the Court as the Regional Teacher Resource Center for New Jersey, and the Ocean County Chamber of Commerce chose Georgian Court College as Educational Organization of the Year. A new library and student lounge area were completed, and seven new graduate degrees were offered.

As the new century dawned in 2000, yet another chapter of Georgian Court's golden history would begin. A new president, achievement of university status, five new and remodeled buildings, the launch of a successful comprehensive Campaign for Georgian Court, and a rapid rise in technology on campus, highlight chapter 6. Needs in poverty-stricken areas of Honduras, the tragedies of 9/11, Hurricane Katrina, and the war in Iraq spur students to merciful acts of service, compassion, and peacemaking.

The story of Georgian Court University is told primarily through photographs and images of specific events, persons, and scenes preserved in the university archives. All pictorial entries relate to some facet of college/university life and have been selected on the basis of availability, chronological representation, and the print quality of the image.

The reader may search this volume without success for a picture of a particular faculty member or administrator, for mention of some outstanding student or graduate, or reference to the reader's favorite tradition. The author apologizes and submits for the reader's enjoyment her best efforts and the untiring work of those who assisted her.

A century of history, of mercy in action, of education transforming lives, of students changing the world for the better, one success at a time—that is the magnificent tapestry and enduring legacy of Georgian Court.

# MISSION STATEMENT

Georgian Court University, founded and sponsored by the Sisters of Mercy, provides a comprehensive liberal arts education in the Roman Catholic tradition. The university has a special concern for women and is a dynamic community committed to the core values of justice, respect, integrity, compassion, and service—locally and globally. Georgian Court University provides students with a curriculum broad enough to be truly liberal, yet specialized enough to support further study and future careers; an environment for the entire community to grow through shared educational, cultural, social, and spiritual experiences; and the will to translate concern for social justice into action.

# *One*

# MERCY BUILDS A COLLEGE
## 1908–1923

*Let us take one day in hand at a time . . . Thus we may hope
to get on taking short careful steps.*

—Catherine McAuley

The opening chapter of Georgian Court's history is a series of firsts. Developing a college curriculum was a new experience for the founding administrators of Mount St. Mary's College, affectionately called "the Mount." However, with assistance from Fordham, Princeton, and other well-established educational institutions, the founders presented the first entering class with a course of study readily approved by the state of New Jersey.

Organization of college-level student clubs, sports teams, and social events, all important to the well-balanced education promised in the Mount St. Mary's College charter of incorporation, challenged the ingenuity of the founders. Many of the young women studying at Mount St. Mary's College in this era were experiencing for the first time an opportunity to be well informed about the social issues of the day. Classroom and extracurricular discussion introduced them to such concerns as the peace efforts of world leaders, the plight of the poor in America, and the problems of European immigrants living in America.

While the founding of Mount St. Mary's College in Plainfield called for adaptations by both its students and founders, society in the United States was experiencing many firsts of its own. The United States was viewed as a world power, and, during this time, became the most highly industrialized nation in the world. Finally, in 1920, the 19th Amendment to the Constitution offered women the right to vote, 12 years after the college was created.

The years spent in Plainfield were also years of growth and of laying the groundwork for the future. By the time the college moved from Plainfield to Lakewood in 1924, a move necessitated by increased numbers of students, faculty, administration, and staff, the equivalent of an organizational chart was in operation. However, the challenge of adapting an elegant sprawling estate to accommodate the needs of a college called for hard work and creativity. As that adaptation progressed throughout the next several decades, the college, newly titled Georgian Court College, was poised to make its mark in higher education for women.

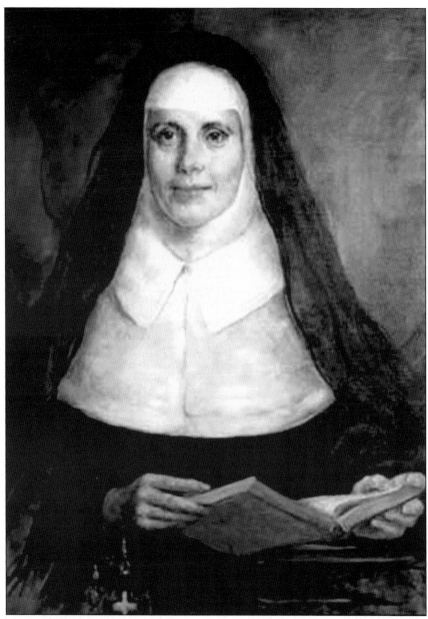

In the house on Baggot Street in Dublin, Catherine McAuley and other women of means attracted by McAuley's charismatic personality and commitment to the poor taught young women dressmaking and other skills with which they might support themselves and contribute to the support of their families. McAuley's school became affiliated with the Irish National School System in 1831 and, in time, the Baggot System, as it came to be called, opened the first training center for Catholic teachers in Ireland. In accordance with the wishes of the hierarchy of the Catholic Church and to assure the continuation of their work, McAuley and her followers formed a religious congregation, the Sisters of Mercy. For their contributions to the field of education, as well as for their service to the sick and the poor throughout the country, the Irish government has, on many occasions, publicly expressed its gratitude to the Sisters of Mercy.

Mount St. Mary's College and Academy for Young Ladies welcomed its first students on September 24, 1908. Perched proudly on a plateau created in the side of the Watchung Mountains in Plainfield, the school is an impressive building constructed of stone hewn from the neighboring hills.

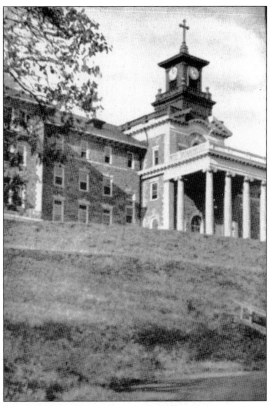

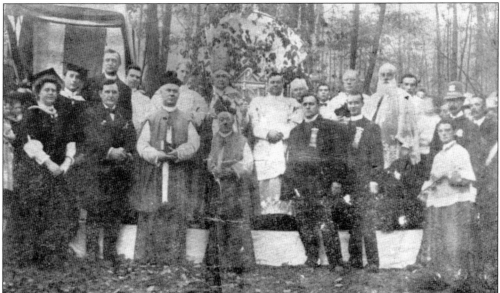

On October 18, 1908, Bishop McFaul, other members of the clergy, and prominent laymen participated in the dedication of Mount St. Mary's College and Academy. An amusing announcement of the dedication printed in the September 3, 1908, edition of the *Plainfield Courier* reads, "Arrangements Being Made for Monster Demonstration at Mount St. Mary's School."

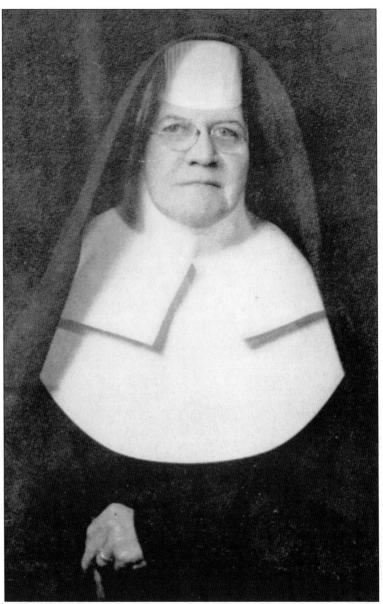

Mother Mary Cecilia Scully, cofounder and first president of Mount St. Mary's College and Academy, supervised the more than two-year construction of the college in Plainfield at a cost of $3 million. She then served as president for 32 years, a term unmatched by any other president. Mother Cecilia's legendary business acumen is said to have compared favorably to that of successful top-level corporate executives—at least that was the opinion of some top-level corporate executives with whom she did business. This may have been why she was chosen to become the bursar of the Sisters of Mercy of New Jersey at the age of 28 and remained in this position even into her presidency. In the Mount St. Mary's archives, Mother Cecilia's handwritten ledger from the early days of the college is still preserved. The ledger's contents speak volumes about her character. She recorded all gifts, regardless of the amount. Gifts of $1 were recorded on the same page as more substantial contributions.

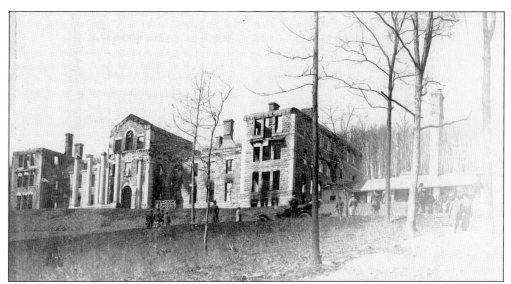

On March 2, 1911, three years after its formal opening, Mount St. Mary's was devastated by a raging fire caused by crossed electrical wires. While all residents of the building were safely evacuated, sadly, the building itself was completely destroyed. However, no sooner had the smoke dissipated than temporary housing and classroom spaces were found and plans for rebuilding were underway.

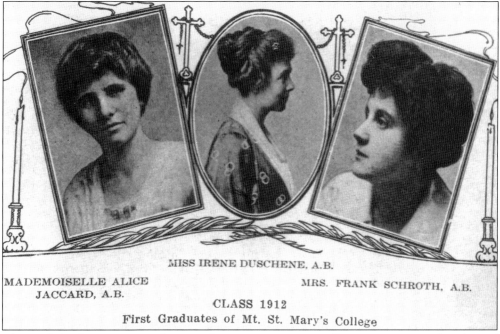

MISS IRENE DUSCHENE, A.B.

MADEMOISELLE ALICE
JACCARD, A.B.

MRS. FRANK SCHROTH, A.B.

CLASS 1912
First Graduates of Mt. St. Mary's College

Three of the first seven graduates of Mount St. Mary's College, comprising the class of 1912, are pictured here. The remaining four graduates were Sisters of Mercy. At that time, it was not considered proper for women religious to be photographed and then only in unusual circumstances. College yearbooks were not exceptions. Similarly, college catalogs listed the religious faculty only as a category—the Sisters of Mercy—rather than by name.

15

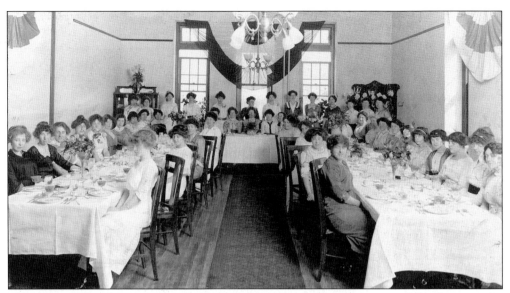

Alumnae and students meet on May 30, 1913. The gathering is one of the first to take place in the dining space of the newly constructed Gabriel Hall two years after the devastating fire. After the fire, Mount St. Mary's was rebuilt. Gabriel Hall was the new wing that enlarged the footprint of the original building.

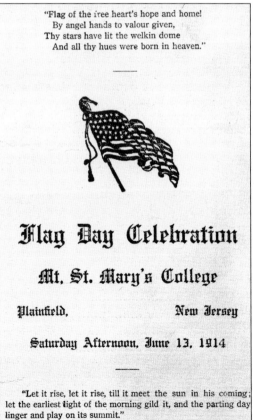

"Flag of the free heart's hope and home!
By angel hands to valour given,
Thy stars have lit the welkin dome
And all thy hues were born in heaven."

## Flag Day Celebration

### Mt. St. Mary's College

Plainfield,                    New Jersey

Saturday Afternoon, June 13, 1914

"Let it rise, let it rise, till it meet the sun in his coming; let the earliest light of the morning gild it, and the parting day linger and play on its summit."

Special events at Mount St. Mary's included national celebrations, such as Flag Day. Observed on June 13, 1914, the Flag Day program included speeches, songs, and the blessing and raising of the American flag. Although the program was planned and written by members of Mount St. Mary's, a women's college, the 11 presenters on the public program were men! However, two renditions by a children's chorus may have included girls.

16

Mount St. Mary's College students show their ankles as they wade in a brook that formed from the wintry runoff of the mountains. The brook flowed through land that the Sisters of Mercy owned in 1914. Today Route 22 runs through this once seasonal waterway.

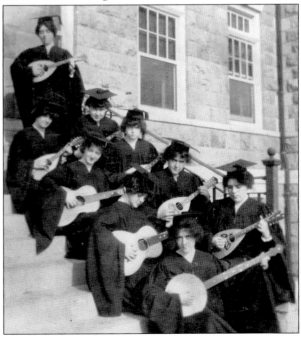

This 1914 photograph of the Mount St. Mary's College Orchestra taken on the steps of the college building raises a question in the mind of the viewer. How did these students, arrayed in mortar boards and long sleeves, manage to play their banjos, guitars, and mandolins?

Mount St. Mary's College students are seen in 1914 on the Old Terrill Road Bridge, located at the foot of the mountain on which the college was built. Today Terrill Road crosses over Route 22, a busy state highway, and leads directly to the entrance of Mount St. Mary Academy.

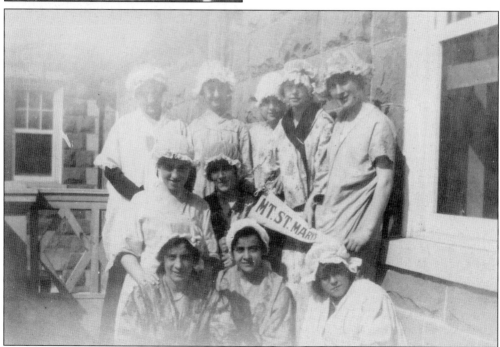

A group of students in nightgowns show their Mount St. Mary's College pride and pennant on the balcony of Gabriel Hall in 1914. La Belle Epoque, 1890–1914, which featured Edwardian costuming, made famous by the Gibson girl style, was just ending when this photograph was taken. The nightcap, worn without exception by this group of students, would soon pass from fashion.

This 1914 photograph shows Mount St. Mary's College students in long white dresses of various styles. As society was changing with the beginning of World War I in 1914, so was fashion. The corseted waist dress, seen in the top left and typical of 1910, was slowly making way for the hobble skirt, seen on the young lady in the foreground. The hairstyle for all the girls, however, was the Edwardian Gibson girl pompadour.

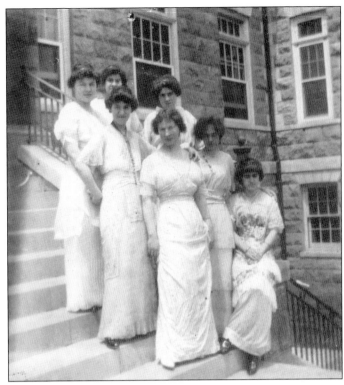

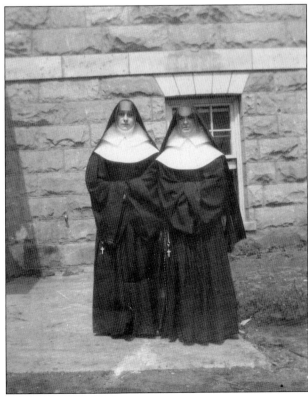

This 1915 photograph shows two Sisters of Mercy in full habit. The habit was patterned after the clothing popular during the time of the founding of the order in 1831. Changes in the dress style for the Sisters of Mercy began in 1967. Today most Sisters of Mercy dress in current-style modest clothing.

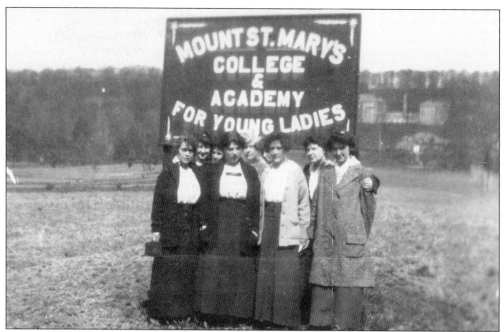

Seven Mount St. Mary's College students pose in front of the "Mount Saint Mary's College & Academy for Young Ladies" sign in 1915. This sign was placed at the foot of the mountain on which Mount St. Mary's was built. The sign is in the area that today is Route 22.

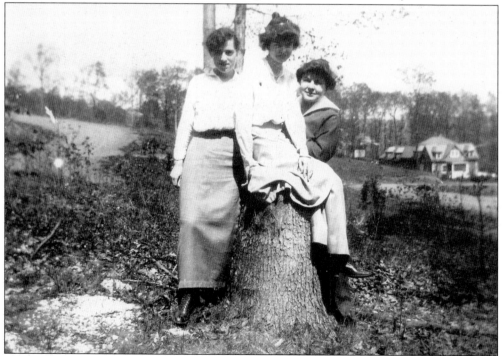

Three juniors in 1915 pose in the picnic area behind the Mount. Looking as though they stepped directly off a fashion plate, these students model the perfect Gibson girl, with hair swept up in loose buns and high-waisted skirts that skim their ankles.

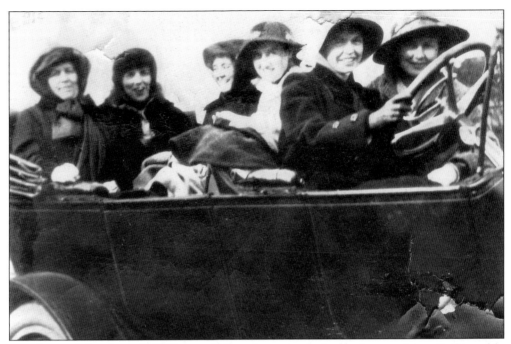

Members of the class of 1915 are off for a jaunt in their touring roadster. Fashionable bonnets and warm woolen coats shield the passengers from the rush of wind as their convertible spins down country roads. In fact, in this Edwardian era, there was a special category of clothing for motoring that took into account open cars and dusty roads.

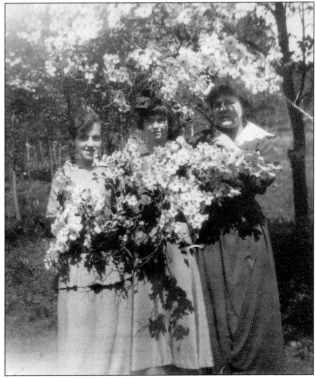

The flowering tree branches, lilacs, forsythia, and a plethora of wildflowers that grew in profusion in the wooded acres of Mount St. Mary's made bountiful bouquets. Here the class of 1916, juniors at the time, hold armfuls of flowers from this idyllic wooded paradise. Flower gathering was a favorite activity, especially during the month of May for the May Crowning of Mary ceremony.

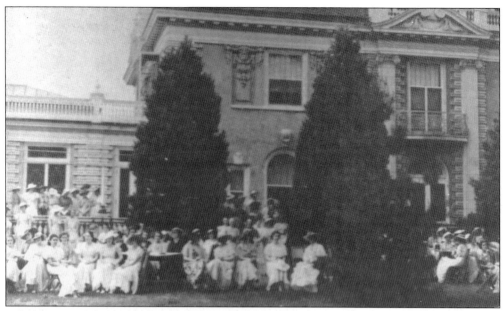

A fantastic and formal gathering took place around 1915 on the lawn in front of Mount St. Mary's College and Academy. Students and parents are in their finest spring regalia. A mother-daughter tea was a springtime ritual at the college.

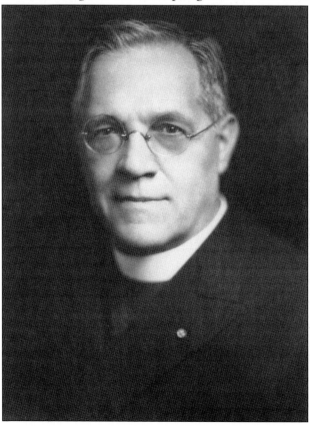

Rev. M. L. Fortier, S. J., dean of the Fordham Graduate School of Sociology and Social Science, assisted the Sisters of Mercy in building a strong curriculum. He also taught courses and conducted the 1918 student retreat. A 1919 yearbook essay recognizes the pioneering spirit of the administrators in engaging his services. The Sisters of Mercy, realizing the superior advantages to be obtained from the introduction of a course in sociology, "affiliated themselves with Fordham University in the development of this work."

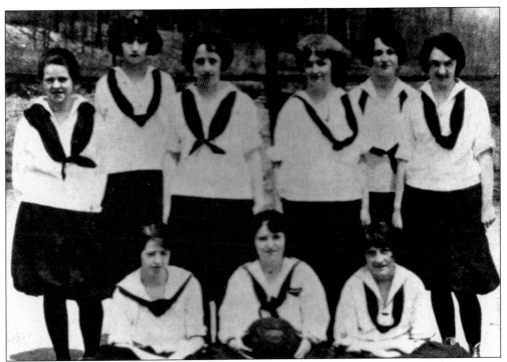

Do not be fooled by the bloomers! The members of the 1923 basketball team were ferocious competitors. The adage "good, better, best, never let it rest, 'til your good is better, and your better is best" applied to Mount St. Mary's College students in the classroom, on the fields of athletic competition, and in their service to their community.

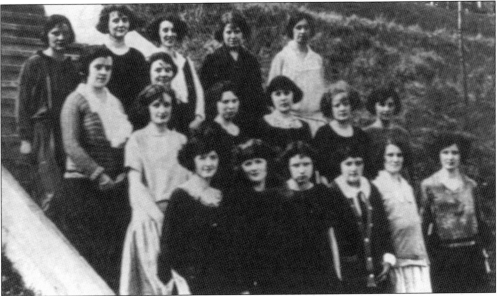

Mount St. Mary's College exposed its students to a smorgasbord of career possibilities—even though they might have been very difficult options in those days. Among them was journalism. The members of the Journalist Club from the class of 1923 pose on the steeply terraced steps at Mount St. Mary's.

Pictured at Mount St. Mary's in the early 1920s, internationally known vocalist Jessica Dragonette '23 attributed much of her success to her experience as a voice student at Mount St. Mary's College and Georgian Court College. She studied under Nicola A. Montani, a member of the college's music faculty, an outstanding musician honored with the title knight commander of the Order of St. Sylvester by Pope Benedict XV. Dragonette was also invited to New York for singing lessons under the renowned teacher Estelle Liebling. Mother Mary Cecilia Scully allowed her to arrange her schoolwork around these trips; even granting Dragonette a leave of absence to stay in New York for extended periods. Dragonette attributed her skill with languages—in addition to English, she sang in German, French, Spanish, Italian, and Russian—to her schooling at Georgian Court. She explained in an interview that "girls enrolled there from all parts of the world, and I picked up a lot in the way of foreign working vocabularies." By 1975, Dragonette would have the longest commercial broadcasting record of any singer in the world.

# *Two*

# THE MOVE
# TO LAKEWOOD
## 1924–1944

*Hurrah for foundations.*

—Catherine McAuley

It came as no surprise when less than 20 years after its founding, Mount St. Mary's College was bursting at the seams with students. Although in the midst of a $300,000 diocesan-wide building fund drive, which would have provided funds for an expansion of the Plainfield campus, the Sisters of Mercy also opened their minds to the possibility of moving to a larger location. John P. Murray, a banker friend of the college whose daughter was being educated by the Sisters of Mercy, discovered that an opulent estate in rural Lakewood, New Jersey, was quietly being offered for sale to a few wealthy prospects. The estate was the home of the late George Jay Gould, who had recently bequeathed his "secondary country home" to his children. Murray approached Bishop Thomas J. Walsh with the suggestion that the Sisters of Mercy buy the estate for the college.

One can only imagine the shocked expressions of the Sisters of Mercy when they first saw the "country home" that the Gould family referred to as "the Court." What stood majestically before them was a lavish estate, with a remarkable resemblance to a college campus, spanning 200 acres of pristine pine forest. Georgian Court was designed by the famed New York architect Bruce Price in the style of an English estate of the Georgian period. The property bordered Lake Carasaljo and featured landscaped bridle paths, magnificent gardens and statuary, a grand esplanade, a lagoon, hothouses, tennis courts, a nine-hole golf course, an enormous carriage house, and long rows of stables. At the heart of the estate was a grand lakeside mansion in which the Gould family and their personal servants resided.

After some negotiation, the Gould family sold the estate to the Sisters of Mercy with the contingency that the estate's name, Georgian Court, be retained. In 1924, Mount St. Mary's College began a new chapter in the small town of Lakewood as Georgian Court College. The college community would spend the next two decades in this idyllic setting against the global backdrop of the Great Depression and World War II. Although the Sisters of Mercy did not know it at the time, their awe-inspiring new home perfectly foreshadowed the exciting future that lay ahead for Georgian Court College.

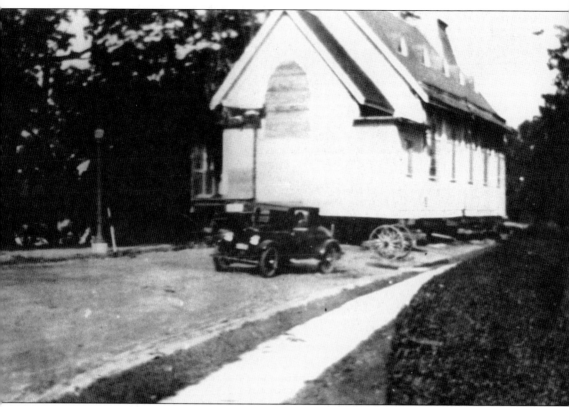

In 1889, Rev. Thomas B. Healy formed the first Catholic congregation in Lakewood and built a frame church for worship. In 1924, when a larger Spanish-style church, known today as St. Mary of the Lake, was built, the original church was donated to Georgian Court College. The above picture shows the frame church being pulled across town on logs driven by a team of horses to the Georgian Court campus, a feat recorded in Robert Ripley's *Believe It or Not!* When the church reached the campus, it was situated at the north end of the former stable area and received Georgian-style trim, buttresses, and stucco to match. It was then renamed the Student Chapel. Today it is designated as the McAuley Heritage Chapel in honor of the founder of the Sisters of Mercy. Appropriately, this space is dedicated to preserving and celebrating the 100-year history of Georgian Court and the mission of the Sisters of Mercy.

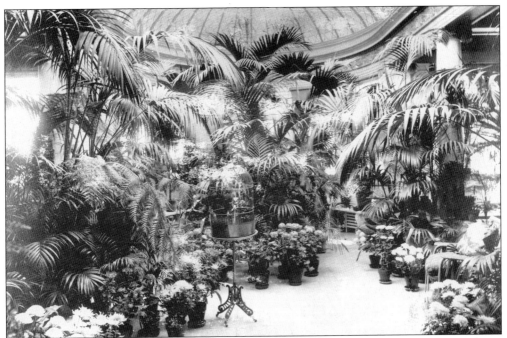

George Jay Gould's wife, Edith, relaxed and tended to her palms, ferns, and potted floral plants in the conservatory, where a leaded-glass roof and windows provided ample sunlight. Built in the style of a temple, the walls and floors were constructed of marble, with benches and wicker furniture for sitting. When the Goulds entertained, the colorful potted flowers were taken out of the conservatory and placed all around the Mansion.

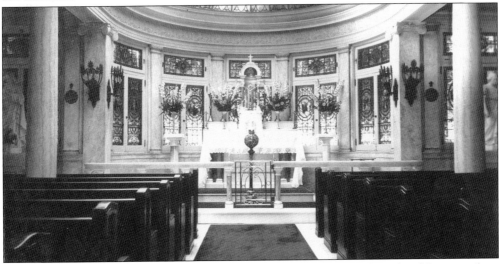

Georgian Court transformed the Goulds' conservatory into a chapel, adding an altar, stained-glass windows, and religious statuary. The stained-glass windows were donated by the Henry Heide Candy Company, which was founded in Manhattan in 1869 and became famous for producing the chewy candies known as Jujubes and Jujyfruits. For many years the chapel provided a beautiful setting for campus community retreats and the Sisters of Mercy's daily masses, celebrated by Rev. Norman Demeck, C.P., S.T.D.

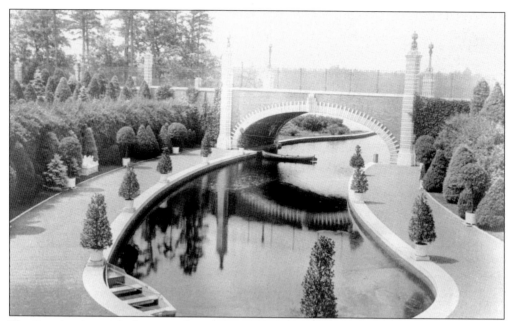

The Lagoon is an ideal setting for twilight socials and firework celebrations, as well as scientific research for students and faculty. Water entering the estate from Lake Carasaljo feeds the Apollo Fountain. The brick pavement, marble stairs, and twin terraces form the classic environment created by Bruce Price, a renowned architect and father of Emily Price, who is known to many as etiquette guru Emily Post.

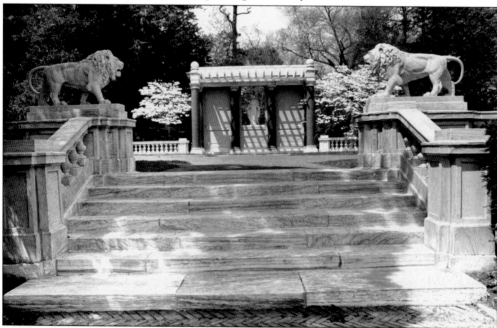

Pictured here are two ferocious-looking marble lions that guard the steps leading down to the Sunken Garden and Lagoon. Visitors to Georgian Court are amazed by the vast array of magnificent statuary that decorates the campus, some of which dates back to the 15th century.

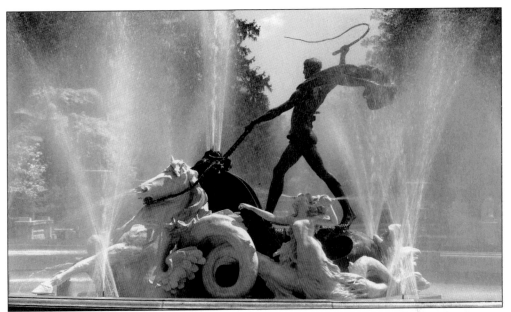

Sculpted by John Massey Rhind, the Apollo Fountain was a birthday gift given by George Gould to his wife, Edith, in 1922. The fountain is a massive bronze in a marble-rimmed basin with a large octopus forming a chariot drawn by a team of sea horses. Today Apollo is a favorite still life for budding student artists and offers a spectacular show for the Georgian Court community during special events.

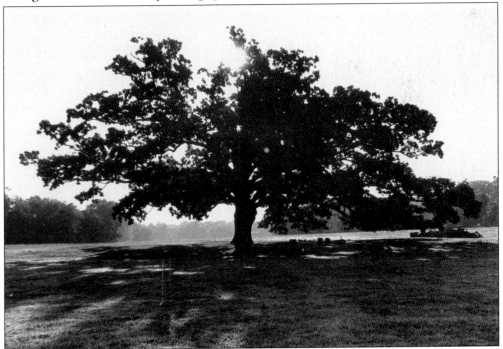

This white oak tree is older than Georgian Court and stands majestically in the center of a large field that was once the Goulds' golf course. The tree is believed by many to be the largest white oak in Ocean County.

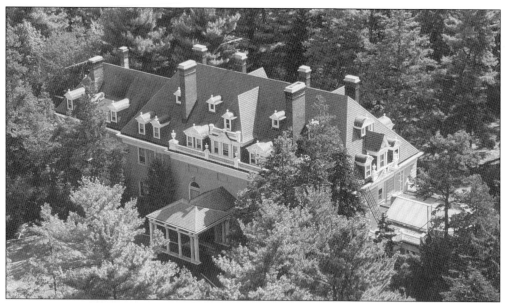

The Mansion originally housed the adult members of the Gould family and guests on the second floor with 11 bedrooms and six bathrooms. The third floor, which had 15 rooms and three bathrooms, housed the Gould children and servants. Still more servants resided on the fourth floor, which contained four bedrooms and one bathroom. The first floor included a great hall entryway, dining room, kitchen, pantries, music room, parlor, conservatory, library, and billiards room.

Upon entering the Mansion, visitors are enchanted by the baroque grandeur of the great hall. Adorning three walls is a mural, pictured here, that depicts the prologue to Geoffrey Chaucer's *The Canterbury Tales*. This spectacular work of art was created by famed New York painter and muralist Robert Van Vorst Sewell.

The Gatekeeper's Lodge at the Seventh Street entrance to Georgian Court housed the Goulds' gatekeeper and his family. In the early years at Lakewood, the college used it as the Practice House for home economics majors. Later the building served as a residence for the college chaplain, and it now houses the Office of Campus Ministry.

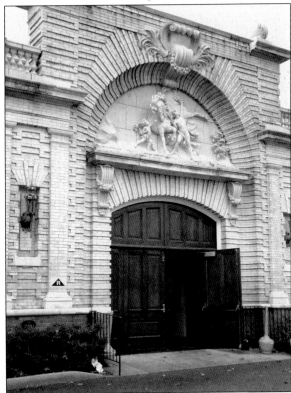

Built in 1899, the Casino was the playground of the Gould family, complete with tanbark ring, swimming pool, three-lane bowling alley, squash and handball courts, court tennis court, and rooms for guests and servants. The sprawling building is now used for administrative and student support offices, athletics, campus gatherings, group activities, and special events.

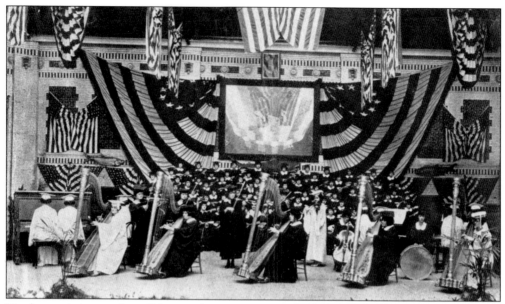

Lively sentiments of tradition and transition marked the June 1924 commencement ceremony. It was the first graduation to be held on the Lakewood campus, and it was the last class of students to receive degrees from Mount St. Mary's College. Shortly afterward, the college officially moved to the Georgian Court estate in Lakewood and was renamed Georgian Court College.

The Big Sister/Little Sister tradition is celebrated here in 1925. For much of Georgian Court's history, first-year students became Little Sisters to junior-year students, who guided them in the ways of the college. This spirit of friendship and mentoring among women is encouraged today in Georgian Court's Women's College with programs such as Women in Leadership Development (WILD).

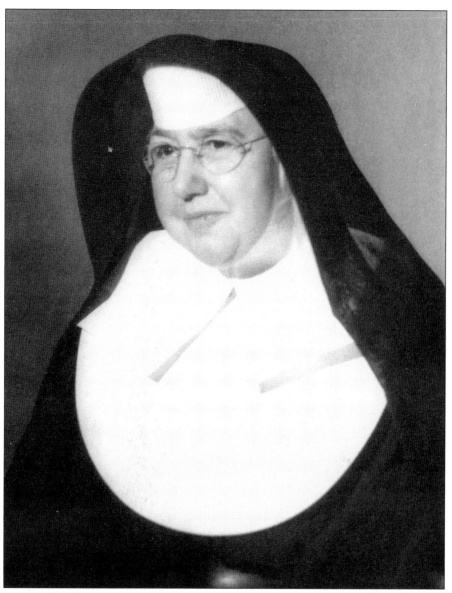

Sister Mary Pius Conlon was born in Ireland to a farming family in 1891. She attended the National School in Kilcorney, which sparked a desire to immigrate to America and continue her education. She worked as a lay sister at Trenton Cathedral and Mount St. Mary's motherhouse before being assigned as temporary supervisor of the Georgian Court kitchen in 1924. Luckily she stayed for 55 years! No amount of effort was ever too much trouble for Sister Mary Pius, who picked fresh produce for meals at a farm behind what is presently the Arts and Science Center. She rose before dawn each day to serve students her famous homemade muffins and biscuits and helped establish the Raymond Hall Dining Hall, which is still in use today. Her special concern for the education of promising young women led her to replace the dining room's professional waitstaff with needy students, a plan that resulted in Georgian Court's first student-work scholarships. Today Georgian Court's work-study program helps many students defray educational costs while gaining experience and serving the campus community.

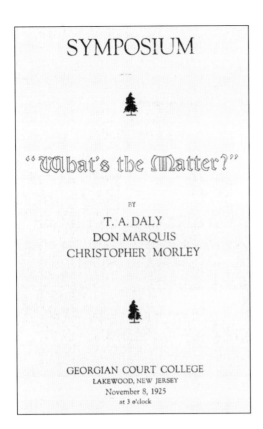

SYMPOSIUM

🌲

"What's the Matter?"

BY

T. A. DALY
DON MARQUIS
CHRISTOPHER MORLEY

🌲

GEORGIAN COURT COLLEGE
LAKEWOOD, NEW JERSEY
November 8, 1925
at 3 o'clock

In 1925, Georgian Court brought together, for the very first time, three contemporary poets of distinction—T. A. Daly, Don Marquis, and Christopher Morley—for a lively symposium. This celebration of poetry included dramatic readings, as well as music by the St. Michael's Orphanage Band of Hopewell, New Jersey.

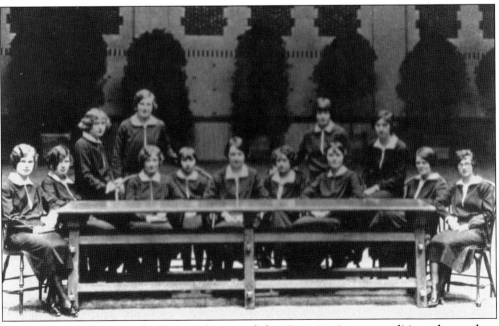

The Georgian Court yearbook is aptly named the *Courtier*. In every edition, the student staff chronicle the special memories made by each class. Pictured here in 1925, the *Courtier* staff takes a break from the hard work that goes into every Georgian Court yearbook.

In 1925, a private residence was moved through Lakewood to the Georgian Court campus. Named after a Sister of Mercy who was the first director of Mount St. Mary's Academy in Plainfield, Mercedes Hall was converted into a student residence. Later it would be used as an art studio, offices, and classrooms.

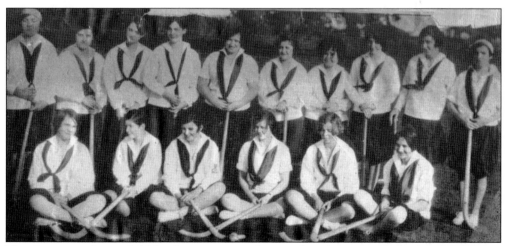

The Georgian Court field hockey team was featured in the November 14, 1926, edition of the *New York Times*. The team is pictured in uniform following a practice scrimmage on the school grounds.

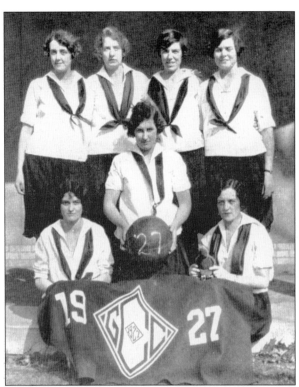

Members of the varsity basketball team of 1926–1927 are pictured in the classic uniforms of the time. Basketball is among the most enduring competitive sports in the history of Georgian Court.

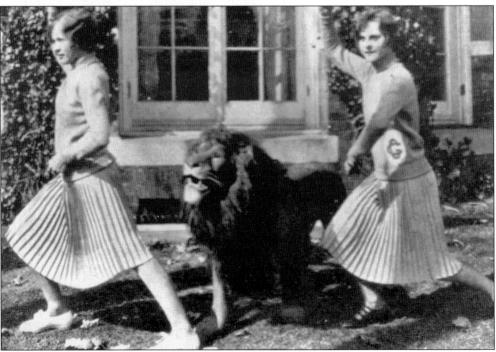

The spirited Georgian Court cheerleaders pose with their lion mascot in 1927. The lion was the obvious choice for Georgian Court's mascot—numerous statuary depicting lions can be found "guarding" many areas of the campus.

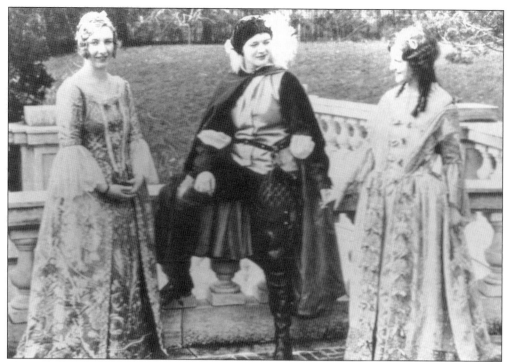

The Georgian Court campus provided a beautiful and classic atmosphere for this 1929 performance of William Shakespeare's *As You Like It*. Pictured in character are (from left to right) Mary Campbell '30 as Rosalind, Rosalie Frenking '29 as Duke Frederick, and Margaret McNamara '29 as Celia.

As early as 1929, the number of students seeking campus residency exceeded space available. Hamilton Hall was the first residence to be purchased by the college outside the wrought iron fence enclosing the estate. It had been built by the Goulds in 1906 and sold to renowned journalist Arthur Brisbane in the 1920s.

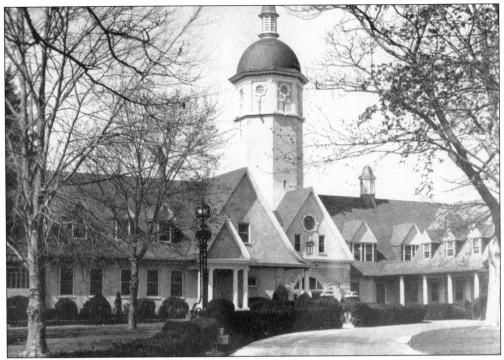

This view of the south side of the buildings now forming the Raymond Hall complex originally housed the Gould family horse stable and small rooms for groomsmen and gardeners. The Goulds employed a legendary 200 gardeners to maintain their estate.

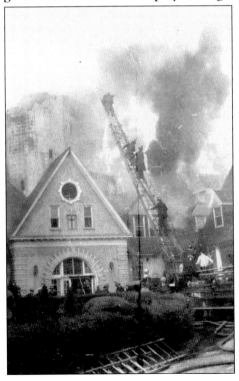

On May 15, 1932, hundreds of guests visiting the college for the annual Musicale concert witnessed a destructive fire in Raymond Hall. The blaze, of unknown origin, caused severe damage to the building. The fire destroyed a distinctive clock tower and a set of chimes that had been imported from England by the Gould family.

Thankfully, no one was harmed in the Raymond Hall blaze. Following the fire, students, pictured here, worked together to salvage clothing and personal items from the damaged building. The structure of Raymond Hall was restored by September of that year, albeit with a few architectural modifications.

While the fire burned in Raymond Hall, students were in the Casino rehearsing for the Musicale scheduled to take place the following day. That somber morning, Sister Mary Beatrice McMullin, Ph.D., who produced the show and was known for her networking skills, placed a call to Steinbach's department store in Asbury Park. The store graciously and quickly delivered new white gowns for every student. As shown in the picture above, the show went on!

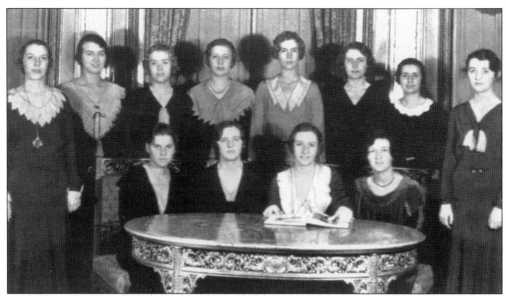

Members of the League of the Sacred Heart, pictured here in 1930, were dedicated to uniting the world with the Sacred Heart of Jesus through prayer. In the spirit of Mercy, they worked to promote awareness of the church and its mission.

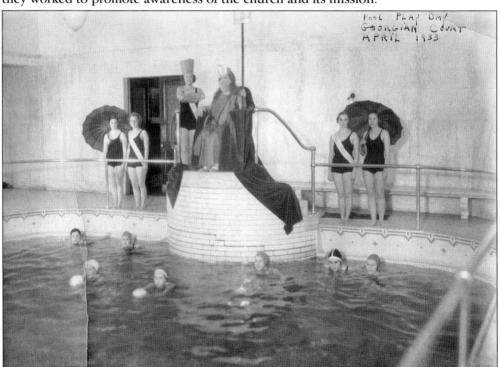

Swimming as an organized sport dates back as far as 2500 B.C. in ancient Egypt and later in ancient Greece, Rome, and Assyria. Perhaps that is why Poseidon, Greek god of the sea, presided over the Georgian Court Pool Play Day in this April 1933 picture. The ornate pool, which to this day delights swimmers in the Casino, is constructed of porcelain-faced brick and surrounded by marble walls, pillars, and benches.

40

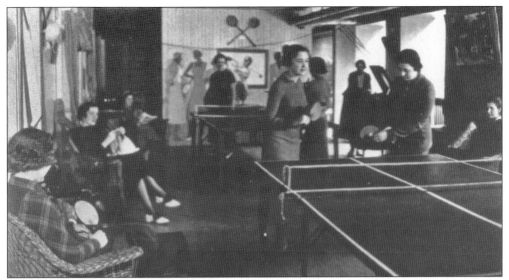

In the 1930s and 1940s, table tennis was a popular sport at Georgian Court and throughout the world—the first official world table tennis championship was held in London in 1927. Pictured above in the 1930s, students relax and play table tennis in a recreation area in the Casino. This area has since been used as a fitness center and is now a locker room for visiting athletic teams.

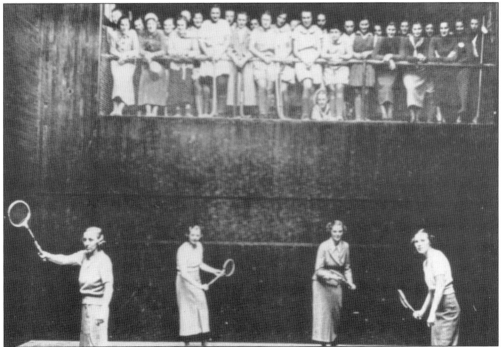

Here the 1936 court tennis team presents their skill to fans. The game of court tennis originated during the 12th century in France and is considered the forerunner of all racquet games. A contender plays the surfaces of the walls, ceiling, and floor, trying to keep the ball out of reach of an opponent. The Goulds' court has been restored and is one of fewer than 10 courts remaining in the country today.

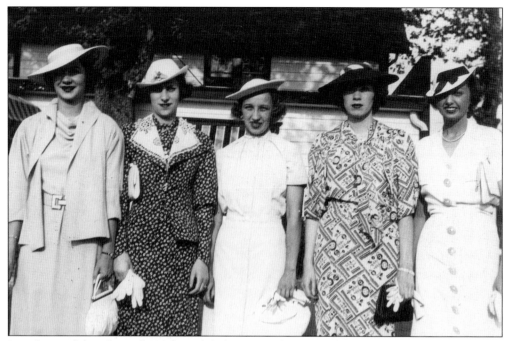

Members of the class of 1936 model their own handiwork. Standing from left to right are Dorothy Jamin, Anita Maresca, Helen "Honey" Auth, Teresa "Tessie" Larkin, and Ruth McLaughlin. To fulfill the requirements of a home economics course, students designed and sewed dresses in the styles of the times.

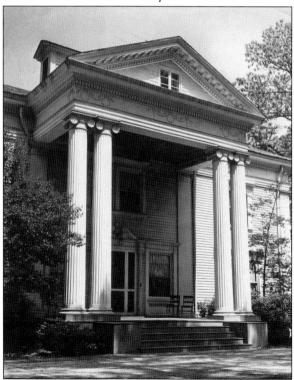

In 1940, Kearney House, later renamed Campus Club, was purchased to serve as a residence and student café with a soda fountain. The building, which faces Lake Carasaljo, is known today as Lake House. It provides office space for the Division of Enrollment Management and the Division of Marketing and External Affairs, including the Office of Public Information and University Communications.

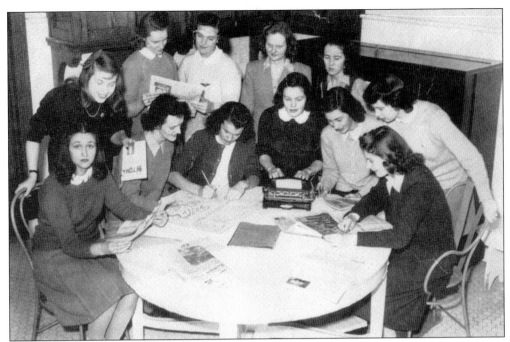

Established in 1943 as the War Activity Commission, this student group sold war bonds and stamps and generally worked to promote greater interest in the war effort. In 1944, it reemerged as the Victory Club and adopted a new purpose: "to back the peace with dollars and cents."

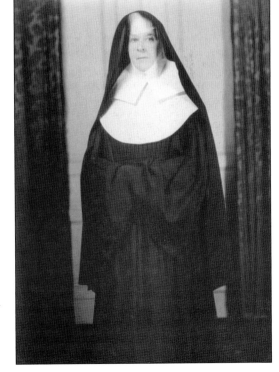

Mother Mary John Considine '12 was dean of the college from 1908 until 1940 and president from 1940 until 1948. In addition to holding these important posts, she was distinguished as the first woman to earn a graduate degree from Fordham University and the first woman religious to earn a degree from a Jesuit university.

From the 1930s through the early 1950s, the Very Reverend Monsignor Fulton J. Sheen, Ph.D., was a frequent guest of Georgian Court. Reverend Sheen, who later became bishop and archbishop, served the college as a retreat leader, guest speaker, lecturer, and friend. An eloquent speaker, Reverend Sheen delivered the commencement address for 10 consecutive years beginning in 1939 and was a lecturer from 1941 to 1951. He also hosted popular radio and television shows, including *The Catholic Hour*, which aired on NBC radio for more than 20 years. His powerful speeches encouraged all who listened to work more diligently toward attaining a meaningful spiritual life. The cause for Archbishop Sheen's canonization was opened in 2002 and, so, it may be that the university will one day add the title "saint" to the record of Archbishop Sheen's presence on campus. A few months before the death of Archbishop Sheen, Pope John Paul II visited St. Patrick's Cathedral in New York and embraced him, declaring, "You have written and spoken well of the Lord Jesus Christ. You are a loyal son of the Church."

# *Three*

# COMING OF AGE
## 1945–1965

*No matter how small the gift, God gives the increase.*

—Catherine McAuley

Between 1945 and 1965, the country and Georgian Court College went through periods of rapid change and growth. World War II ended, and Americans went on to enjoy a period of prosperity previously unimagined. The cold war brought about fears of communism, and the United States fought threats in Korea and Vietnam, and waited tensely through the threat of nuclear attack with the Cuban Missile Crisis. Americans saw the civil rights movement and the space race unfold and experienced the tragedy of John F. Kennedy's assassination.

In education, more and more women—and their families—were embracing the idea of higher education. In 1946, only 77,510 American women received bachelor's degrees. By 1965 that number had increased to 217,362—an increase of more than 180 percent.

Georgian Court College itself began to expand beyond the original estate and some previously donated or purchased buildings by constructing three new buildings—Farley Memorial Library in 1952; St. Joseph Hall, a residence hall, in 1961; and the Arts and Science Center, an academic building, in 1964. These buildings served the increasing number of students who were coming to the Court from as far away as Japan, China, and the Philippines, as well as those from New Jersey and nearby states. By 1964, a $4.7 million fund-raising campaign was also underway, proving Georgian Court's dedication to a future of educating the generations of women to come.

Despite these changes, this period of Georgian Court history was also very much about tradition. The college celebrated its Golden Jubilee—the first 50 years as an institution of higher education—on October 12, 1957, with a pontifical mass and a papal blessing. Each class looked forward to the events of college life, including Sophomore Weekend, Junior Prom, Class Night, the Holly Hop, Musicale, Christmas carols at the Mansion, and the Ring Banquet. While many of those traditions have been replaced by others, the students of this time period started new sports, clubs, and a legacy of service that still prevails today.

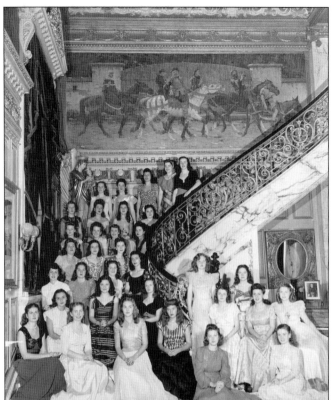

The post–World War II class of 1946 showed off its finery for a class photograph on the Mansion's marble staircase. Not 10 years prior, during growing tensions with Japan, Manhattan boycotters had staged an "anti-silk parade," and students from 150 universities had thrown silk stockings and ties into a bonfire at a New York women's college campus.

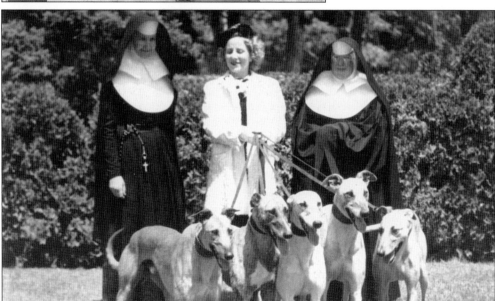

Jessica Dragonette '23, shown here with her greyhounds on an alumnae weekend, returned to Georgian Court many times to sing "Ave Maria" in the annual spring Musicale. On one such occasion, the *New York Times* noted "Musicale Draws 3,000—Jessica Dragonette Is Soloist at Georgian Court College, Lakewood, New Jersey." Dragonette's fondness for her alma mater lasted until her death in 1980.

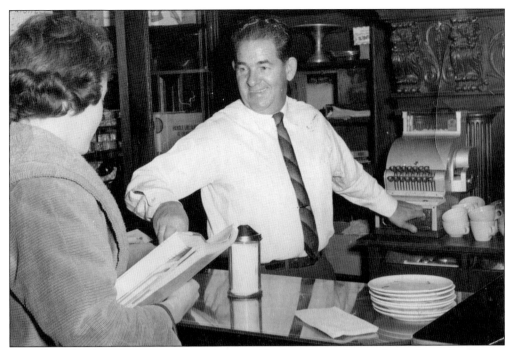

Patrick and Julia Gavan were longtime and beloved members of the Georgian Court staff. The couple managed the student café in the Campus Club (known today as Lake House). Orders were delivered with a broad smile and a lively Irish wit. Patrick (shown above) also served as an emergency plumber, reliable driver, mail services worker, and later, as director of special services for college personnel.

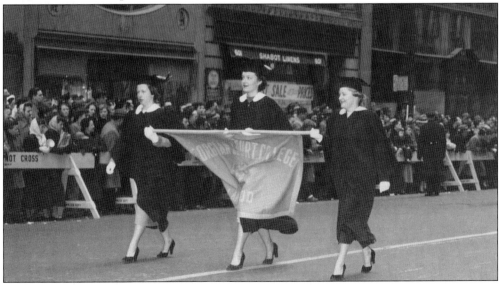

The New York City St. Patrick's Day parade drew students from nearby colleges; Georgian Court was no exception, particularly because of its Irish heritage. Proudly displaying the college banner in this photograph are Georgian Court students from the late 1940s, including Elizabeth Quinn '46, student council president (center), and Lois Driscoll '48, secretary of the Camarata Club (right).

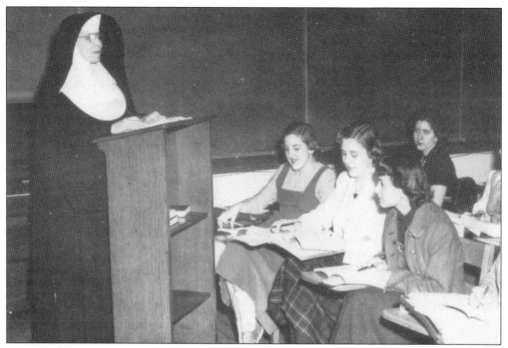

Sister Jane Frances Ferguson, Ph.D., '25 was a professor of philosophy at Georgian Court College for 43 years. Students will remember the diminutive Sister of Mercy carrying a briefcase that was almost larger than she was. In her required philosophy class, she was known for speaking about "the 'deskness' of the desk." In the 1940s, she introduced the National Federation of Catholic College Students to the Georgian Court campus.

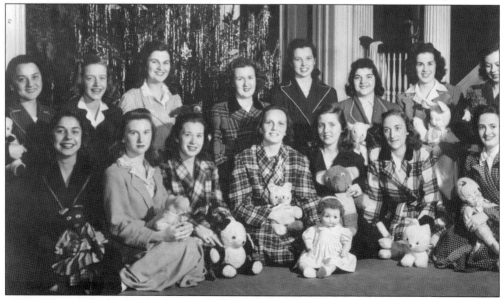

The student café with its soda fountain was a popular meeting place in the Campus Club, while the two upper floors served as a residence hall. At Christmastime, each of the residence halls had their own Christmas celebrations. Here some of the 1947–1948 Campus Club residents pose with their favorite stuffed animals.

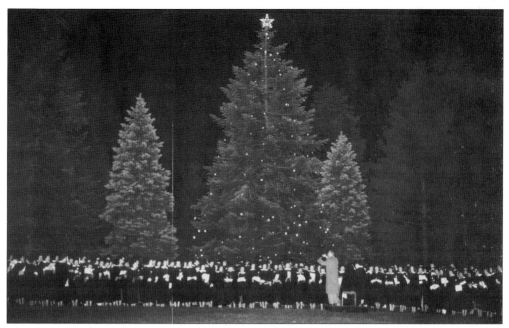

Christmas traditions come and go. For many years at Georgian Court, the student body, nearly all of whom were residents, gathered in front of the Mansion to sing Christmas carols. These 1947 carolers, dressed in caps and gowns, sing under a brightly lit fir tree. The tradition continued into the 1960s.

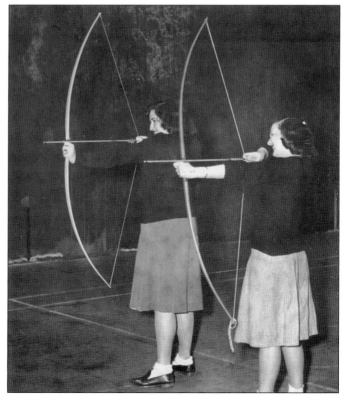

In the fall of 1947, the Athletic Association Council ratified a new constitution that made collegiate sports intramural and set up a point system for eligibility. Students needed to earn at least 50 points annually and maintain a C average. Students received points for competing in tournaments and other events; first- and second-place team members earned bonus points. Here these 1948 archers compete for points toward emblems (250 points) and coveted white blazers (600 points).

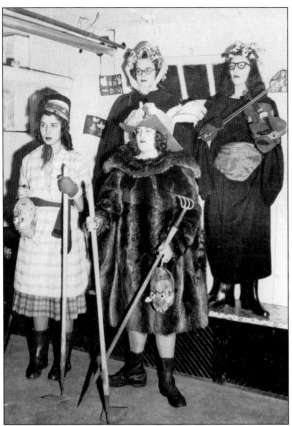

In 1925, one of Edith Gould's hats was found by a group of students, inspiring them to begin an unusual club—Pitra Mitra (Latin for "embroidered hat"). The honorary society chose students who had "a sense of humor and the ability to make others laugh." This merry society provided "comedy or unusual entertainment" for the campus community. The 1948 officers of the club—the crown, vice crown, band, and brim—are shown here.

The class of 1949 seems ready to race Apollo and his chariot. Somehow they managed to bring a cart and horse onto campus to pose for a picture for their parents. Their tribute reads, "You have made it possible for us to go forth and take our place in the world with confidence. We feel that all that we are and all that we will be we owe to you."

50

The particular athletic activities played at the Court have varied quite a bit over the years. In 1950, "genteel" activities dominated. At right, the Equestrian Club poses with its noble steeds at the Ninth Street Gate. The horses were boarded at nearby stables in Howell and Jackson Townships, but often ridden on campus. Golf was another sport played on campus. The popularity of women's golf was on the rise that year, illustrated by the formation of the Ladies Professional Golf Association (LPGA). The Goulds, who were avid golf fans, maintained a competition-size course located where the Arts and Science Center and library are today. The golf course that the students used was located on what is now a soccer field.

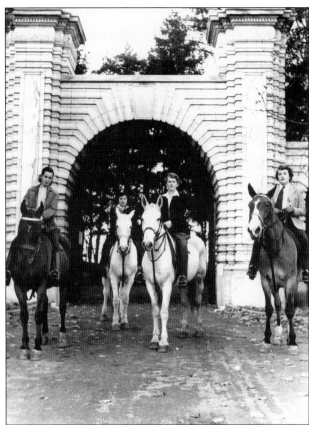

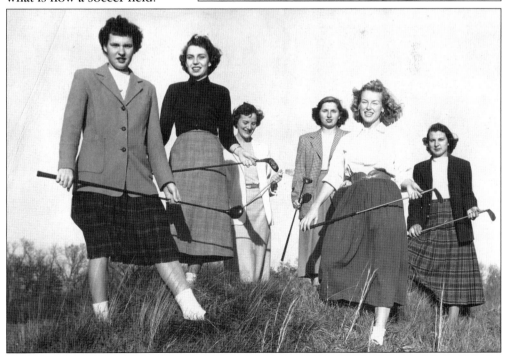

51

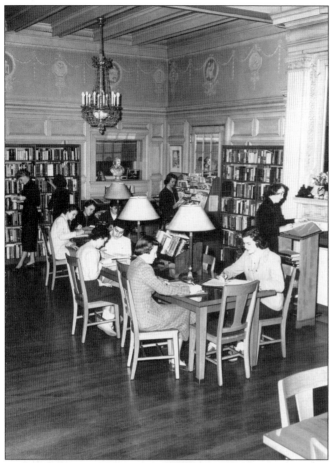

For the first 28 years in Lakewood, Georgian Court College "made do" with its arrangement to provide students and faculty with library services. The sports lounge and ballroom of the Casino (at left) served as office space, as well as a browsing area for a book collection. Additional books and magazines were housed in central gathering rooms of the residence halls. On August 6, 1951, the ground was broken for a much-needed library. It would be the first building constructed since the 1924 purchase of the property. Many Sisters of Mercy were on hand for the ceremony, which occurred during the summer school session when many of them were students. The Sisters of Mercy in the photograph below seem to be enjoying the ride on the construction vehicle.

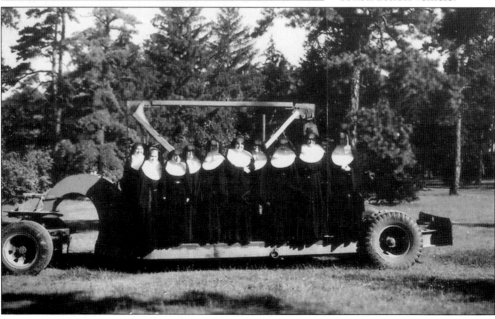

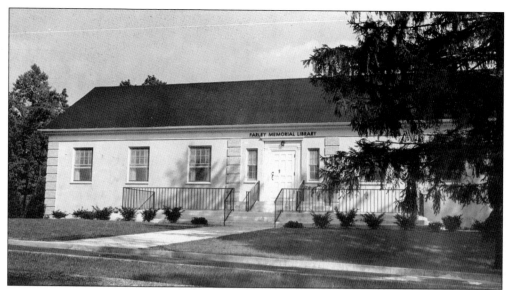

The completed Farley Memorial Library was dedicated on May 16, 1952. It was named for Patrick Farley, a benefactor of the college and father to Sister Mary Patrice Farley '27, who served as the college librarian from 1942 to 1957. The first students to use the new library were Sisters of Mercy taking summer school classes. Today the original building, along with its 1974 addition, is known as Farley Center.

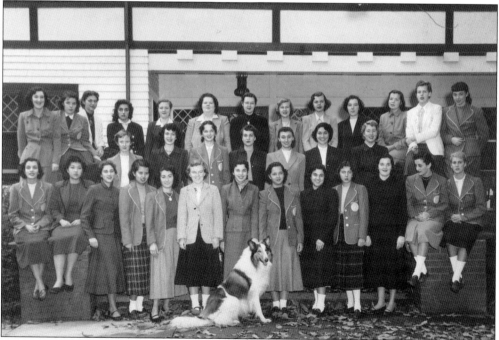

Campus security in the early days of Georgian Court in Lakewood was not much of a concern. Patrick Gavan was always available to respond to calls for assistance, but there was also Laddie, a collie who served as more than a pet. Shown here with the class of 1953, Laddie was the trustworthy and beloved watchdog for the residents of the original Lake House on North Lake Drive, the building farthest from the main campus.

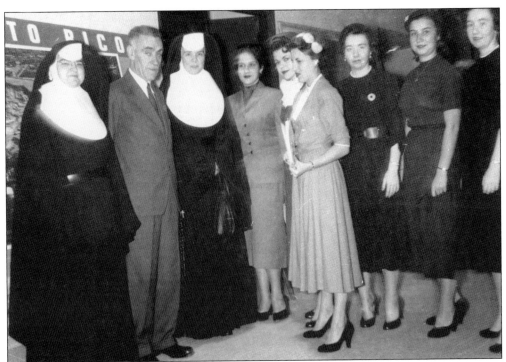

On November 21, 1953, several students and Sisters of Mercy attended the Puerto Rican Conference in the United Nations Plaza. The keynote speaker was Dr. Federico De Onís (second from left), a Spanish intellectual, poet, and critic who lived in Puerto Rico and New York and was crucial in defining the area of Hispanic studies. On his left is Sister Mary Muriel Lynch '48, and to his right stands Sister Mary Pierre Tirrell '30, future Georgian Court College president.

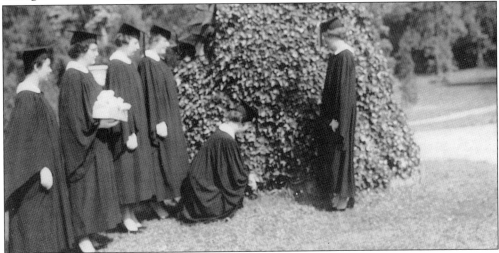

Each year at commencement, processing graduates stop to plant ivy at the base of *The Eagle*. Because ivy hooks its climbing stems and clings tightly to walls and tree trunks—or in this case, a statue base—it represents fidelity. Georgian Court graduates thus declare their faithfulness to their alma mater. Here the class of 1955 pauses to make their contribution to the ivy of the classes who preceded them.

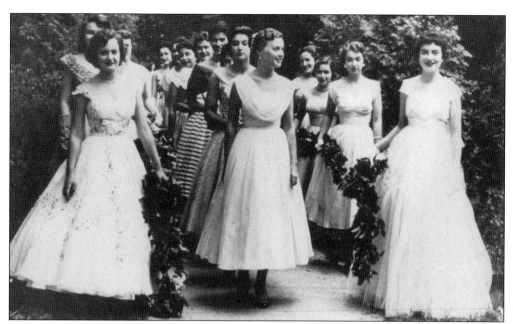

Another traditional commencement event at Georgian Court, shown here in 1956, was the Laurel Chain or Laurel Procession. Seniors dressed in pale pastel dresses and processed to Class Night in the Casino, flanked by rows of their "Little Sisters" carrying chains of laurel. Laurel leaves, symbolizing achievement or honor, were chosen to recognize the accomplishments of the graduating class.

Consider a typical bill issued by the College Business Office in 1956. The annual cost of tuition, board, and student fees amounts to nearly 25 percent of the average U.S. household's spending for that year. Bills in 1956 and 1957 also included $10 for a "gymnasium suit" and $28 for laundry service.

### GEORGIAN COURT COLLEGE

Lakewood, N. J. ......Sept., ......195 6

Miss Mariluise Jones ..................................

**To SISTERS OF MERCY, Dr.**

| First Semester— September 1956 to | February 1957 |
| --- | --- |
| Registration Fee | $ 10.00 |
| Tuition & Activities | 275.00 |
| Board | 300.00 |
| Residence | 75.00 |
| Laboratory Fee | 10.00 |
| Court Page and Student Body Dues | 13.00 |
| Letter Box & Locker (rental for year) | 4.00 |
| Chest X-Ray | 1.00 |
| | $ 688.00 |
| Credit: Concession $ 275. | |
| Deposit 35. | 310.00 |
| | $ 378.00 |

Pay to the order of Georgian Court College and forward to the Treasurer

Sister Mary Joan Brady '31 served Georgian Court College for nearly 50 years. Like many of the Sisters of Mercy, she served on the faculty, teaching courses in education and in Latin. However, she would be most likely remembered for her role as treasurer of the college from 1954 to 1960 and, again, from 1968 to 1991.

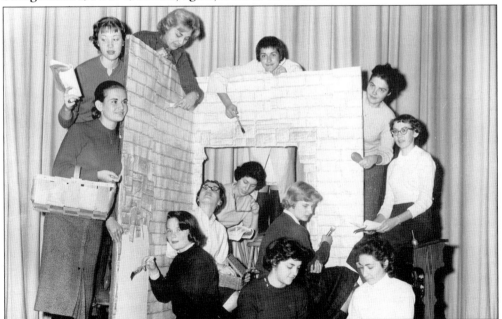

The Court Players brought theatrical performances to the campus. By participating, the members of the group also developed "poise, the art of expression, and the ability to communicate effectively." Here Court Players paint sets for a 1958 production of *The Years of the Locusts,* a play about the departure of a community of cloistered Irish Benedictine nuns from their motherhouse in Ypres, Belgium, in 1914.

Another sport that has come and gone at Georgian Court is field hockey, shown here being played in 1959. Although the sport has been played in the United States since 1901, women's field hockey did not make it as an Olympic sport until 1980. This bodes well since field hockey is expected to be a team sport at Georgian Court again by 2010.

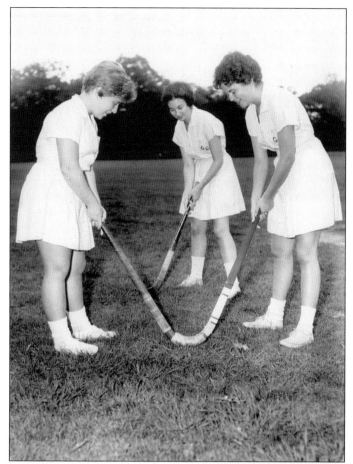

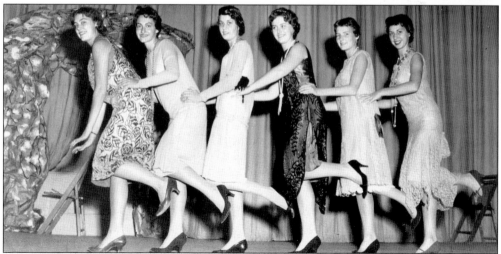

At the 1959 freshman talent show—with the theme "Doin' What Comes Naturally"—the 1920s roared again. Members of the class of 1962, in borrowed but authentic flapper dresses, brought that exciting era to life. Shown from left to right are Georgia Mudd, Doreen Squillante, Joanna Lyons, Patricia Moriarty, Carol Zum Brunnen, and Angela Safko.

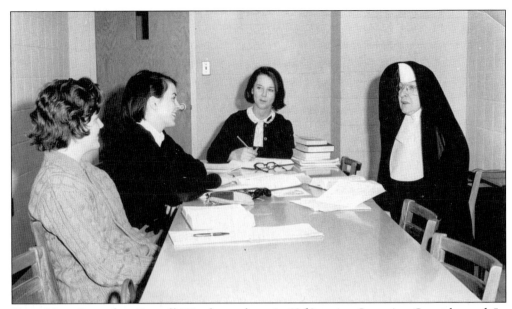

Sister Mary Consolata Carroll '20, shown here in 1960, was a Georgian Court legend. In 1916, before entering the convent, she was employed by Mount St. Mary's College as an assistant in cookery. Her initial contract gave her a $200 annual salary, $200 carfare for two trips home per year, and a $50 raise per year. Later, as a Sister of Mercy, she taught English at Georgian Court for 58 years, authored two books, and published poetry.

Born of necessity to house an increasing number of students, Georgian Court broke ground on May 4, 1960, for St. Joseph Hall, the first modern residence hall. It was designed to accommodate 150 residents—144 students in double rooms and six hall deans in single rooms. Mother Marie Anna Callahan '12, Georgian Court president, holds the first spade of dirt while (from left to right) a local associate pastor, auxiliary bishop, and college chaplain look on.

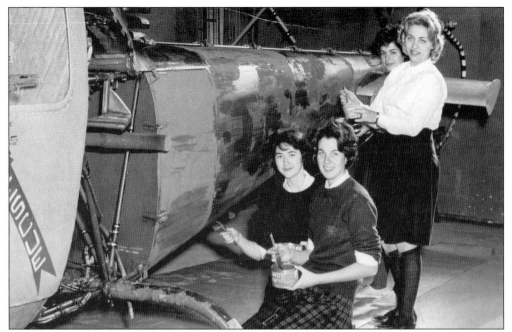

Georgian Court's core value of service has been manifested in many ways during the college's history. One way the students provided service to their country was to support the military. On December 1, 1960, Georgian Court College students painted Christmas messages on a search and rescue helicopter at the nearby U.S. Naval Air Station in Lakehurst. However, this was not their first "paint job"—Georgian Court received a Good Neighbor Award for the same practice in 1956.

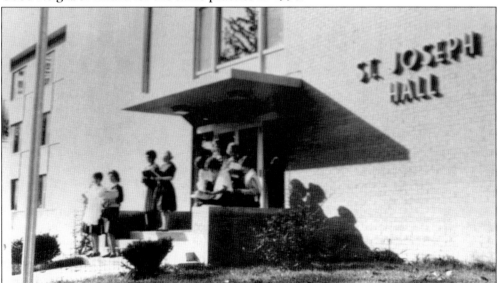

On Mercy Day (September 24) 1961, the cornerstone of St. Joseph Hall was laid, and the building was ready for occupancy. This modern residence hall alleviated the overcrowding of the prior year, in which singles had become doubles, doubles triples, and triples quads. The opening of St. Joseph Hall also brought with it the first lay housemother. Housemothers took charge on weekend nights, when students kept later hours.

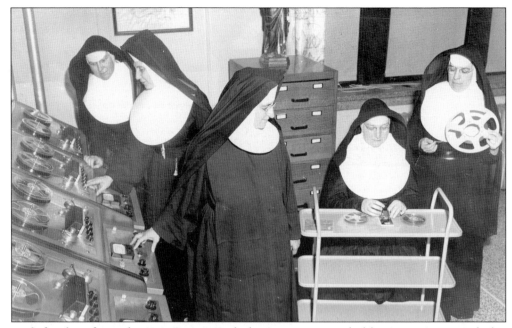

With funding from the New Jersey Catholic Science Roundtable, Sister Mary Nicholas Farley '47 (seated) conducted a 1961 summer workshop for science teachers at New Jersey Catholic schools. Here the teachers are learning how to use tapes in their science instruction. Sister "Nick" served as chair of the Department of Physics and dean of women, and also taught education classes. Her elementary science book series was widely used throughout New Jersey and beyond.

Classroom space was at a premium by the early 1960s. Here students leave classes in Kingscote; classes were also held in Raymond Hall, Raymond Hall West, the Casino, and Mercedes Hall. After the Arts and Science Center was completed in 1964, the classrooms in Kingscote were remodeled as administrative offices, and many administrators were able to work together in one building.

In 1962, the physical education classes required for freshmen and sophomores featured gymnasium uniforms reminiscent of the All-American Girls' Baseball League. For many years, physical education was taught by Jeannette Lippmann, a former Rockette. The gym training she offered included doing gymnastics to music and learning dances in preparation for a "Gym Show." It seems that the Court never lost sight of the fact that wellness included spirit, mind, and body.

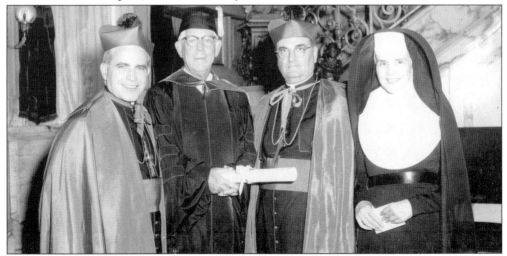

In 1963, John McCarty (second from left) received the first honorary degree awarded by Georgian Court. McCarty, a successful business owner and benefactor of the college, is pictured here with (from left to right) John J. Dougherty, bishop of the Archdiocese of Newark; George W. Ahr, bishop of the Diocese of Trenton; and Sister Mary Pierre Tirrell '30, president of Georgian Court.

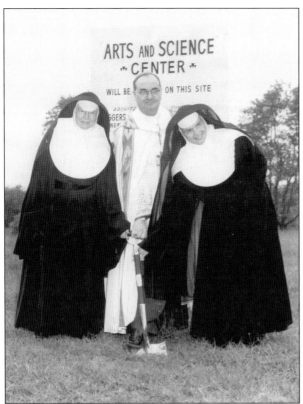

Increasing enrollment proved a need for a dedicated building for classroom instruction. On September 15, 1963, Mother Mary Patrick McCallion '16, major superior of the Sisters of Mercy of New Jersey; Bishop George W. Ahr; and Sister Mary Pierre Tirrell '30, Georgian Court College president, broke ground for the Arts and Science Center. Plans included wings for music, art, and science; a "Little Theatre" with 150 upholstered seats; and a language laboratory. The building was dedicated on December 11, 1964.

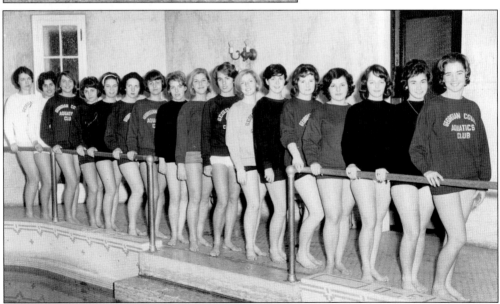

The Georgian Court Aquatics Club poses by the pool for its 1964 yearbook photograph. Each member of the club was required to pass lifesaving tests prior to admission. The club offered an annual aquatics show featuring water ballets, comic stunts, and precision diving. The Court pool, built for the enjoyment of the Gould family, not competition, is not used for intercollegiate events due to its size.

Sister Mary Peter Coakley, Ph.D., '47 demonstrates the use of a spectrophotometer, which identifies chemicals in body fluids, to senior Christine Ann Pelczar '64. Sister Mary Peter served as professor and chair of the Department of Chemistry. She was known for her success in securing grants for the science departments—which is most likely how this particular equipment was obtained and made available to students.

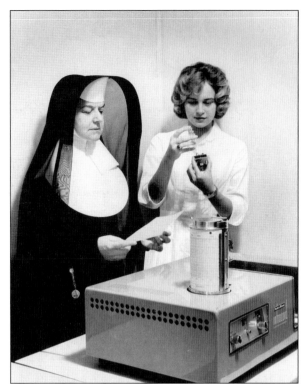

In this 1964 candid yearbook photograph, three students chat with beloved philosophy professor Norman Kavalec (right) in front of Raymond Hall. The caption that appeared under the photograph reads, "Judging from the nature of material things, Mr. Kavalec, what would you say were the chances that this pedestal will support all four of us?"

Members of the class of 1964 responded to John F. Kennedy's challenge to "ask what you can do for your country" with service in the Peace Corps. Shown here with Latin instructor and Peace Corps liaison Mary Anne Hartigan '59 (center), are Elizabeth Koch (left) and Maureen McCudden (right). After graduation, Koch was stationed in Nigeria and McCudden in Costa Rica.

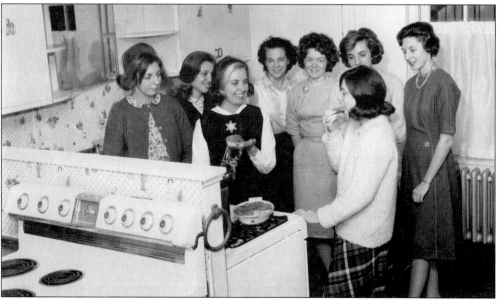

For many years, home economics was a popular social science major for many Georgian Court College students interested in pursuing home economics for home, school, and business purposes. Classes took place in the Practice House (what is now the Gatekeeper's Lodge). The Home Economics Club hosted annual spaghetti dinners and spring fashion shows. In this 1964 photograph, Sylvia Rusnock, chair of the Department of Home Economics (right), observes her class.

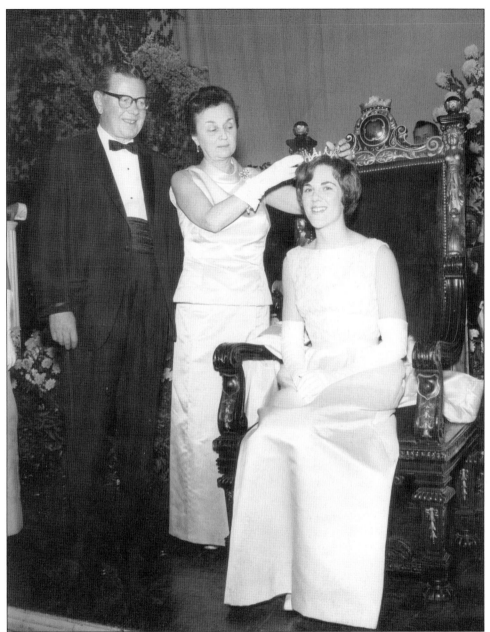

Richard J. Hughes, governor of New Jersey, looks on as Princess Maria Antónia de Bragança, Infanta of Portugal, crowns Ellen Mullane '64 queen of the "April in Rome" Gala. Mullane and the members of her court were chosen by the student body. The gala was a Georgian Court dinner-dance benefit held on April 22, 1964, in the Trianon Suite at the New York Hilton. The *New York Times* reported that the proceeds of the gala would "help the college's [fund-raising] campaign to reach $4.7 million for a science and arts building, a chapel, a new residence hall, and other facilities." In 2005, Ellen and her husband, Jerry Gallagher, received honorary degrees from Georgian Court for their foundation's work on achieving peace and prosperity through education. The Gallaghers also maintain two scholarships at Georgian Court, one in honor of Ellen's mother, Anne White Mullane '30.

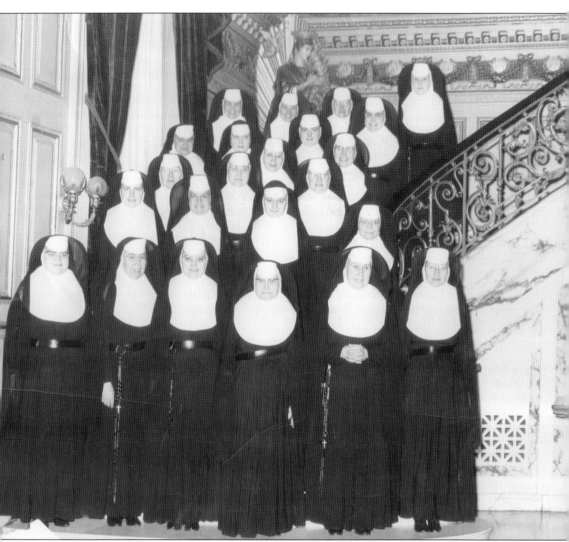

Twenty-three Sisters of Mercy pose on the Mansion's sweeping marble staircase. The Sisters of Mercy served Georgian Court as administrators, faculty, and staff. Most are also alumnae. Included in this 1965 photograph are five of Georgian Court's eight presidents—Mother Marie Anna Callahan '12 (1940–1962; first row, fourth from left), Sister Mary Pierre Tirrell '30 (1962–1968; top left), Sister Mary Stephanie Sloyan '39 (1968–1974; bottom right), Sister Maria Cordis Richey '50 (1974–1980; second row from top, second from right), and Sister Barbara Williams '63 (1980–2000; second row from bottom, left). The uniformity of their religious garb was soon to be a "habit" of the past, as the Sisters of Mercy adopted a modified habit only two years later. This would be the first change to the "dress of the day" in over a century, proving that the 1960s was a time of change for more than just the college campus.

# *Four*

# CHANGING WITH THE TIMES
## 1966–1986

*Do not fear offending anyone. Speak as your mind directs . . . and always act with courage.*

—Catherine McAuley

These words from Mother McAuley were the order of the day for the United States—indeed the world—throughout the late 1960s, the 1970s, and the early 1980s. From Haight-Ashbury and the war in Vietnam, to the gas shortage and disco, to the Iranian hostage crisis and the advent of MTV, these years were a corridor of change for the nation, with the rise in activist movements and numerous tumultuous and controversial world events.

Georgian Court was not untouched by these events. Attitudes toward women's higher education were changing, the formalities of years past giving way to new horizons for women in the workforce and in the world. New Jersey launched the county college system, with nearby Ocean County College as the first in the state, triggering an influx of more culturally and economically diverse students to campus.

The increase in student population and diversity brought a wealth of new perspectives. New student organizations were formed, and political and social debate took place regularly in and out of the classroom. There was an increased focus on social justice and globalization, with groups like the Center for Christian Concerns and events like Peace Week and International Week inviting the examination of the changing world.

Academically, the college underwent its greatest change since moving to Lakewood: the 1976 creation of a coeducational graduate program with a master of arts in education. For the first time, men were invited to take classes alongside women after 4:00 p.m. In 1979, the coeducational undergraduate program followed, offering select undergraduate programs to women and men that would allow them to work during the day and further their education at night.

Georgian Court became a center for more than academics. The historic campus was well known in the area for its stunning architecture and botanical beauty, and was a popular place for alumni nuptials. In 1977, Hollywood even used the campus for a scene in *The Amityville Horror,* a movie being filmed at a house in nearby Toms River.

Throughout this era of rapid and dramatic change around the world, Georgian Court kept pace by inviting students to investigate their roles in the modern world and to consider the ways in which they could make contributions for positive change.

Begun during World War II to free more men for combat duty, the Women's Army Auxiliary Corps (WAAC) were the first women in the army who were not nurses. The WAAC was established to work with the U.S. Army "for the purpose of making available to the national defense the knowledge, skill, and special training of the women of the nation." After meeting with enormous success, the WAAC was integrated into the army as the Women's Army Corps (WAC) after only two years. The WAC employed women in a host of positions, from the traditionally female switchboard operators and office clerks to the typically male airplane armorers and automobile mechanics. By 1966, when women were needed to support the burgeoning Vietnam War, the WAC Junior College Program had two proud enlistees from Georgian Court: Eileen Conway '66 and Carole Sherman '66. The WAC remained a separate part of the U.S. Army until 1978, when women were fully assimilated into all but the combat branches of the army.

In 1967, Georgian Court awarded an honorary degree to Mildred Barry Hughes '23 for her leadership in political, social, and humane causes. Hughes, shown here addressing the New Jersey Federation of Women's Clubs, became the first woman in the New Jersey Senate. Her legislative agenda focused on the welfare of people with special needs, including senior citizens and the mentally and physically challenged.

Sister Mary Stephanie Sloyan, Ph.D., '39 served as Georgian Court president from 1968 to 1974, a time of student unrest on campuses around the country. During her term, students gained representation on campus committees and formed the Georgian Court College Council. Sister Stephanie also encouraged the recruitment of students for summer session. Until the 1960s, the chief patrons of summer session were Sisters of Mercy. In 1973, enrollment had increased 77 percent over the previous year.

In May 1968 the alumnae association again hosted an antique show in the Casino, a favorite fund-raiser for many years. That year, the Casino also hosted Little Anthony and the Imperials in a concert sponsored by the sophomore class. The doo-wop group was known for such hits as "Tears on My Pillow" and "Shimmy Shimmy Ko Ko Bop."

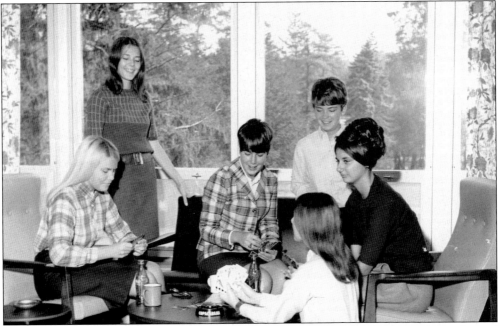

Penny loafers and plaid were the uniform of the day for these members of the class of 1970, who are relaxing with a couple of Cokes and a game of cards in the second-floor lounge of St. Joseph Hall.

Vincent Tomes, Ph.D., Georgian Court's first layman to serve as academic dean, announces the 1972 update and expansion of the curriculum, including the approval of two new major programs—special education and psychology—that grew to be two of Georgian Court's most popular majors.

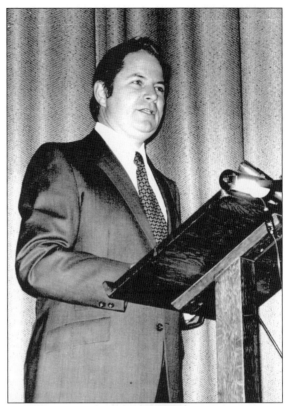

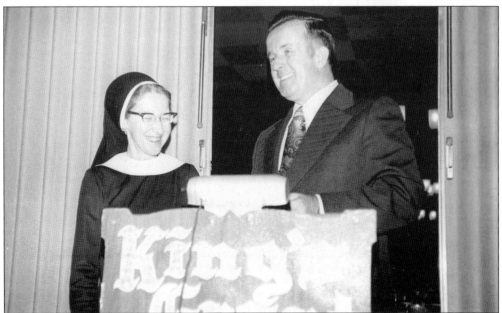

Sister Mary Stephanie Sloyan, Ph.D., '39, Georgian Court College president, graciously accepts a $1,000 donation from Fathers' Club president Edward Carroll at the King's Grant Inn in Point Pleasant in 1972. Although the Fathers' Club no longer exists, its sentiment is upheld through a very popular annual father-daughter dance.

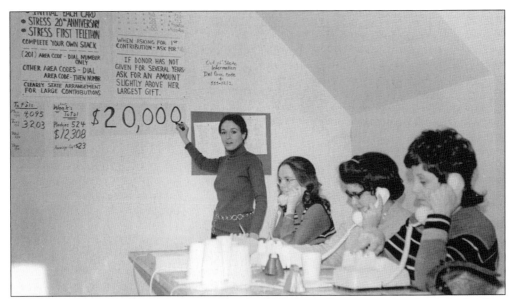

In 1973, student volunteers gathered to raise $20,000 for the Court through the first Phonathon, a two-week marathon of telephone calls reaching out to alumnae. A successful fund-raiser, Phonathon remains one of the cornerstones of Georgian Court's Annual Giving Program, providing alumni with the opportunity to speak with current students and reconnect to their alma mater.

Sister Maria Cordis Richey, Ph.D., '50 began her term as Georgian Court College president in 1974. Her six-year tenure featured the inception of the coeducational graduate and undergraduate programs, an enrollment increase of 71.6 percent, the return of the business administration major after a 10-year absence, and the placement of the campus on the National Register of Historic Places. Today Sister Maria Cordis is a much-loved professor of English.

The 1973 Court Notes stand ready to entertain on the steps of the great hall in the Mansion. Formed in 1963 by several members of the Glee Club, the Court Notes performed current hits and even choreographed a few numbers.

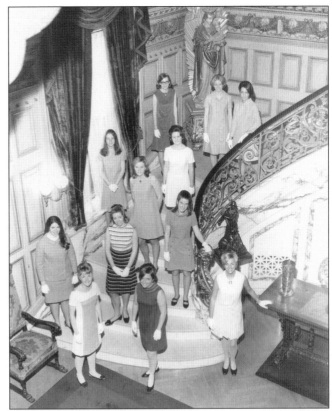

One of the benefits of being so close to New York City is going to see Broadway shows. Here Georgian Court students sit with Carol Channing after a performance of *Lorelei*. The trip was sponsored by the Cultural Affairs Committee of the Student Government Association.

This artistic shot reflects a typical afternoon in the pub, a popular student hangout on campus for many years. Students would go to the pub to have a beer, relax, and perhaps hear some live music or poetry readings after classes were finished for the day. Students now relax in the Gavan Student Lounge, and the pub has been restored as the Casino Ballroom, a location often used for club gatherings and administrative meetings.

Following an unbroken tradition at the college, the 1976 academic year opened with the celebration of the liturgy in the Student Chapel. Student participants Gloria Telencio '77 (center) and Robyn Saul '80 (right) chat with Sister Maria Cordis Richey, Ph.D., '50, president of Georgian Court (left); Lawrence Dalton, professor of mathematics (second from left); and Fr. Brian Egan, O.S.B., (second from right) as they await the signal to begin.

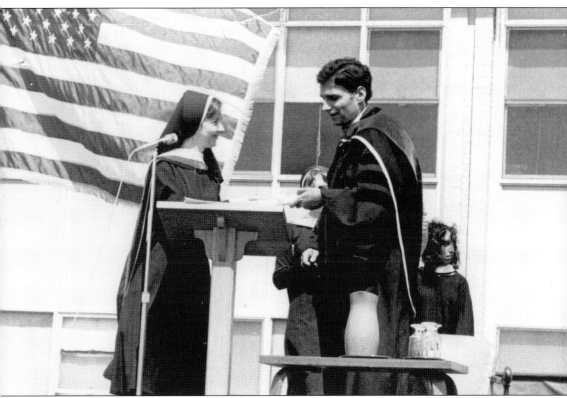

Sister Maria Cordis Richey, Ph.D., '50, Georgian Court College president, presents renowned political activist Ralph Nader with an honorary degree at commencement in 1976. An advocate for democracy, consumer rights, feminism, environmentalism, and humanitarianism, Nader is one of many noteworthy individuals who have been awarded an honorary degree by Georgian Court in recognition of esteemed accomplishments that have supported shared values. Other recipients include actresses Helen Hayes and Loretta Young, New Jersey governor Thomas Kean, authors Joyce Carol Oates and Mary Higgins Clark, opinion pollsters George Gallup Sr. and George Gallup Jr., inventor Buckminster Fuller, U.S. Congresswomen Margaret Chase Smith and Millicent Fenwick, and U.S. Congressman Christopher Smith. Georgian Court has granted more than 50 honorary degrees since the first was granted in 1963—nearly half of those to women of distinction.

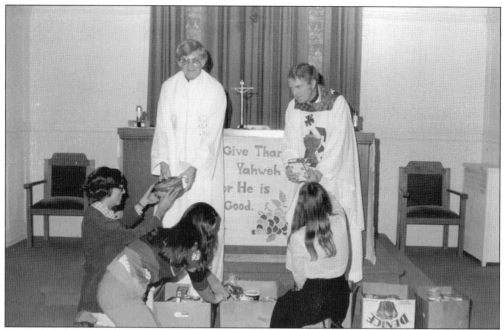

Students from the class of 1977 help Rev. Norman Demeck, C.P., S.T.D. (left), and Rev. Brian Egan, O.S.B., bless food donated by students during a special Thanksgiving holiday mass. Gathering food for less fortunate families at Thanksgiving is a long-held tradition at Georgian Court that continues today through the Office of Campus Ministry.

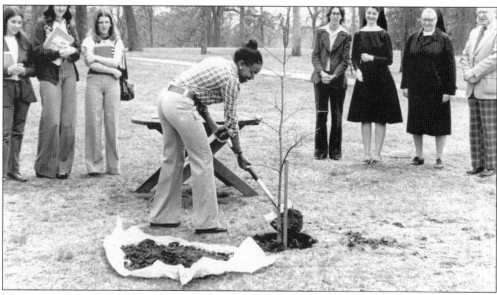

Alumna Naomi Evers '75 plants a tree on the oak knoll in celebration of Arbor Day. Environmental awareness has long been a prominent concern for Georgian Court students and is today recognized annually each spring on Arboretum Day, an afternoon that unites students and faculty from a variety of disciplines in a celebration of nature.

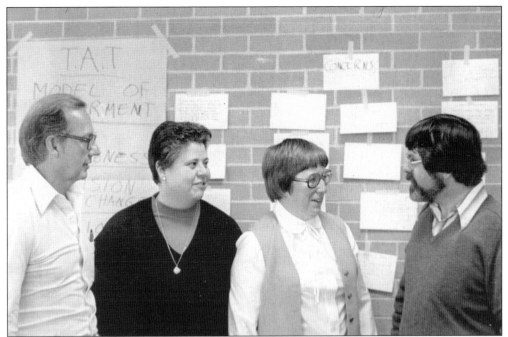

Sister Francesca Holly '69 (left) and Sister Edwarda Barry, Ph.D., '59 (right) codirect the Center for Christian Concerns. Working with two producers from Television Awareness Training, the sisters and the center endeavored to help people assess both the positive and negative impacts that television has on their lives. During the 1980s, the center's educational program was presented on campus and to various church groups, educators, parents, and other interested parties throughout New Jersey.

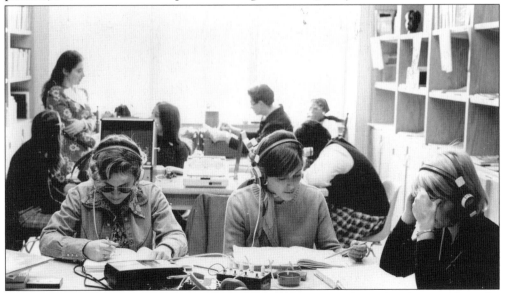

This photograph from the 1978 college catalog shows students hard at work in the McShain Language Lab in the Arts and Science Center. Georgian Court has educated many students and future language teachers in a variety of world languages over the years, including French, Spanish, German, Italian, and Latin.

Mary Gundrun '25 was one of the students who moved with the college from Mount Saint Mary's in Plainfield to Georgian Court in Lakewood. She served as the first president of the Student Government Association. Dedicated to serving her alma mater, Gundrun received the first Alumnae Association Service Award in 1973.

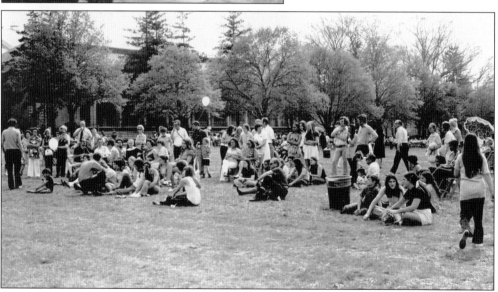

One of the highlights of the 1977–1978 academic year was the Western Fair and Bar-B-Q held on Sunday, May 7, 1978. Many campus constituents united to make it a special day, including the Student Government Association, the alumni association, the board of lay trustees, and the Fathers' Club. Representatives from each group worked together to create a campus carnival on the athletic fields that included live music, a fashion show, pony rides, and games.

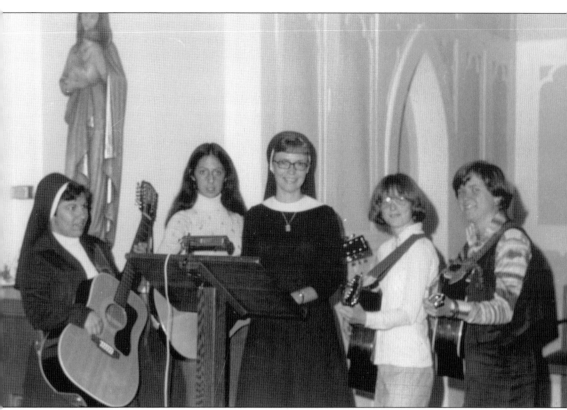

September 24 marks Mercy Day for Georgian Court and all Sisters of Mercy as a celebration of the founding of the Sisters of Mercy by Catherine McAuley on September 24, 1831. The Sisters of Mercy remember their promises and mission through a special mass, prayers, and time set aside for the observance of the day. At Georgian Court, the day takes on special significance as the entire campus community unites in appreciation of the Sisters of Mercy's unique contributions to Georgian Court. Here Georgian Court College's 70th anniversary Mercy Day is celebrated in 1978 by (from left to right) Sister Margaret Scarpone '79; Judith Beebe '79; Sister Mary Catharine Sullivan '55, assistant professor of Spanish; Nancy Resua '81; and Marianne Holler '84.

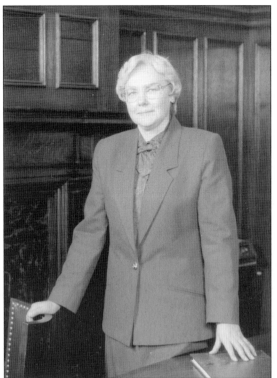

Sister Barbara Williams '63 became president of Georgian Court College in 1980 and held the position until 2000, a length of service second only to founding president Mother Mary Cecilia Scully. Sister Barbara's term saw many historic occasions at the Court, including the 75th anniversary celebration, the naming of the campus as a national historic landmark, and the dedication of the campus as a Peace Site.

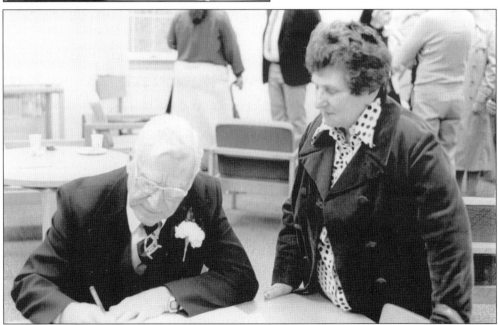

Donald J. McGinn, Ph.D., revered author and member of the Department of English, is shown here signing a copy of his book *Thomas Nash* in 1981. Dr. McGinn also authored *John Penry and the Marprelate Controversy*, published in 1966, as well as numerous articles throughout his teaching career. A loyal supporter of Georgian Court and a kind friend to the Sisters of Mercy, Dr. McGinn is remembered as a scholar and a gentleman.

In 1982, Sister Mary Christina Geis '49 (seated), a longtime professor of art, published *Georgian Court: An Estate of the Gilded Age*. The book remains the definitive record of life at Georgian Court during its years as the Gould family's country estate. Here Sister Christina signs a copy for Sister Joyce Jacobs '67, fellow Department of Art faculty member, and Linda Kavulich '76, director of library services, at a book-signing party in the Mansion.

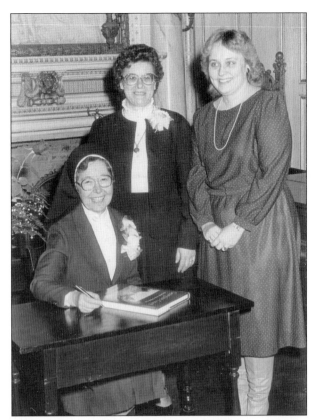

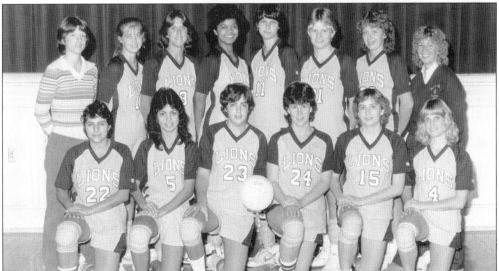

Long gone are the one-piece jumpers and choreography displays. The 1982 volleyball team was the National Association of Intercollegiate Athletics (NAIA) District 31 champion, led to victory by coaches Ann Mastasio '80 (back left) and Leslie Unger (back right). The intercollegiate volleyball team began in 1972 and lasted until 1985. The sport was revived in 2001 as one of Georgian Court's National Collegiate Athletic Association (NCAA) Division II teams.

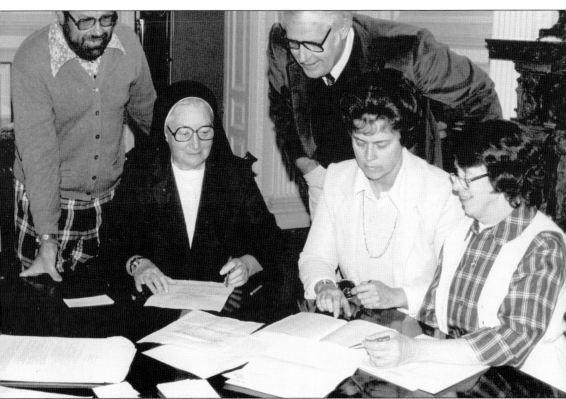

Sister Mary Nicholas Farley '47, professor of chemistry (seated left), and Sister Mary-Theresa McCarthy, Ph.D., '57, professor of world languages (seated right), were both associates of the prestigious Danforth Foundation. The foundation is a philanthropic organization established in 1927 by the founder of the Ralston Purina Company, William H. Danforth, and his wife, Adda. Until 1997, when the foundation ceased its national scope in order to focus on metro St. Louis, Missouri, it extended help in the form of fellowships or scholarships to many college students and teachers across the country. Here the Sisters of Mercy work with other committee members to plan a 1983 conference funded by the foundation. Highlights of the 22-college event included a keynote address on "Education and Inspiration" and a featured lecture titled "Ethics in a Pluralistic Society." The lectures were followed with a wine-and-cheese party and campus tour.

# Guide rates Georgian Court a '10'

LAKEWOOD — Georgian Court College, now in its 75th year, recently rated a "10" among the best colleges for women in a survey conducted by the Feminist Press and published in a catalogue called "Every Woman's Guide to Colleges and Universities."

Georgian Court was rated equal to the College of New Rochelle, N.Y.; Carlow College, Pittsburgh, Pa.; Mount Holyoke, Mass.; Barat College, Lake Forest, Ill.; St. Joseph's College, Hartford, Conn., and Marymount College, Tarrytown, N.Y.

The guide is designed to provide information about colleges not usually contained in standard college guides, including the percentage of female students and faculty leaders and the availability of day care and health and counseling services for women.

Also included in the guide is the percentage of female students in non-traditional majors, the number of rapes reported on campus and the college's policy on sexual harassment.

The guide describes Georgian Court as outstanding in providing leadership positions to women students, faculty and administration.

It states that 63 percent of the full-time faculty are women, which is above the average for similar colleges.

The guide makes special note of the Women's Studies Program, a 12-credit minor offered through the departments of English, history, philosophy, psychology, religious studies, sociology and languages.

The publication ranked 600 colleges in five categories, awarding up to three stars for curriculum and athletics and for the percentage of women leaders among the students, faculty and administration.

Although no college received a perfect "15," Wellesly, Mass., received a "14" while only three other schools were rated above Georgian Court.

In 1983, Georgian Court gained yet another feather in its cap when a survey conducted by the Feminist Press for *Every Woman's Guide to Colleges and Universities* rated Georgian Court a 10 out of a possible 15. Only four schools ranked higher. The Court was praised for providing outstanding leadership opportunities to female students, administration, and faculty. The surveyors noted that an impressive 63 percent of Georgian Court's full-time faculty were women.

The class of 1985's Patty Cooney, Lisa Clark, and Joanne Mooney demonstrate that the newborn tradition of Irish Afternoon is in full swing in 1983. Irish Afternoon was initiated that year as a fund-raiser in celebration of the heritage of Catherine McAuley. In 2007, the Court celebrated Irish Afternoon with a concert by the world-famous Irish Tenors.

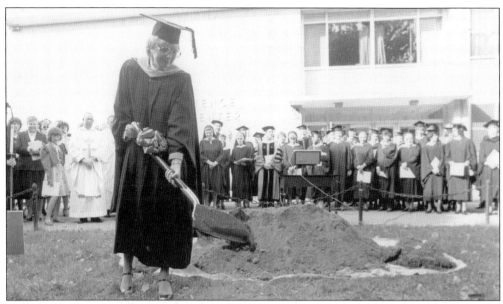

Above, as part of the college's 75th anniversary events, Sister Barbara Williams '63, president, buries a time capsule in front of the Arts and Science Center on October 9, 1983. A joint project of the Department of Business Administration and Economics and the Business Club, the time capsule contains a student handbook; a copy of the 75th anniversary issue of the student newspaper, the *Court Page*; an anniversary plate; and items from each academic department. Below, Sister Barbara greets Bishop John Reiss, Diocese of Trenton, prior to celebrating the 75th anniversary mass. To the left of Sister Barbara stands past president Sister Mary Stephanie Sloyan, Ph.D., '39, and to the right of the bishop stand Sisters Mary Raphael Triggs '56, Mary Catharine Sullivan '55, and past president Maria Cordis Richey, Ph.D., '50.

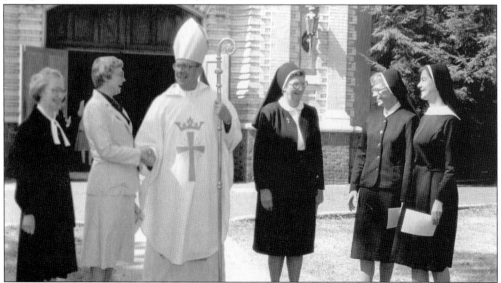

In April 1984 the Court celebrated Peace Week in honor of becoming the first Catholic college in the United States to be dedicated as a Peace Site. To the right, Louis Kousins, founder of the Peace Site program, greets Sister Barbara Williams '63, Georgian Court College president, at the dedication ceremony on April 11, 1984. Kousins envisioned the sites as centers of education for peace, where programs and plans for peace would be initiated, reinforced, and expanded. From its earliest days, Georgian Court has been such a center. Below, driving home the need for peace, a life-size representation of a cruise missile was brought to campus. The Sisters of Mercy driving the car caused quite a stir as they cruised down Route 195 with the cruise missile strapped to the roof.

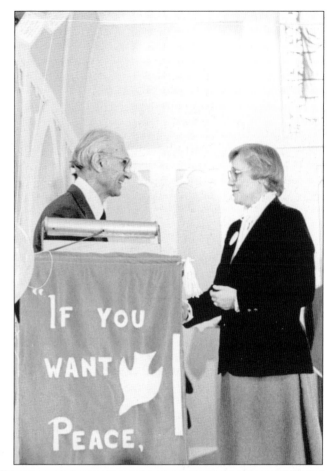

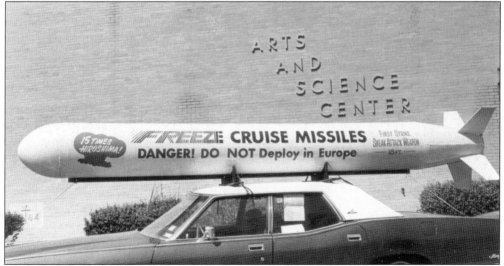

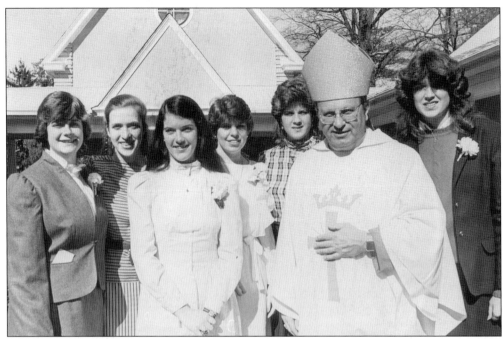

In 1984, the first Georgian Court College students were mandated as ministers of the Eucharist. The Most Reverend Edward Kimiec, auxiliary bishop of the Diocese of Trenton, (pictured with students from the classes of 1985 and 1986) presided. The mandating ceremony grants one the privilege of participating in the Eucharistic liturgy as a server of sacred bread and wine. Today the Office of Campus Ministry mandates Georgian Court University Eucharistic ministers each year.

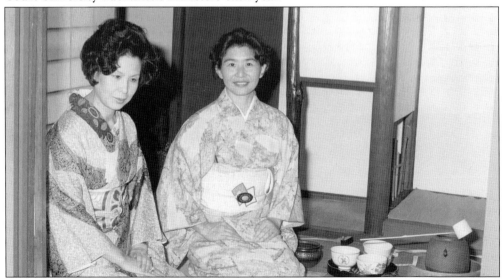

International Week in the spring of 1984 was packed with programs that celebrated the expanding global village—from lectures on international trade and aeronautical research to discussions on aging, religion, art, and education. The week kicked off with the Meet the World Festival, which featured an authentic Japanese tea ceremony demonstrated in the historic Japanese Garden teahouse.

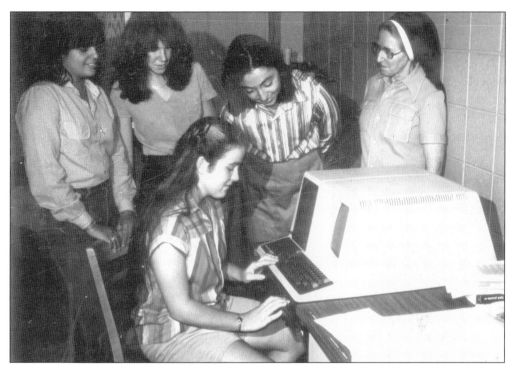

The Court enters the computer age! Members of the class of 1984, along with Sister Mary Stephanie Sloyan, Ph.D., '39, past president of the college and chair of the Department of Mathematics, check out the first computer on campus. The computer was housed in the math lab and gave many students their first taste of the technological revolution. Computers were brought in for administrative use the following fall semester.

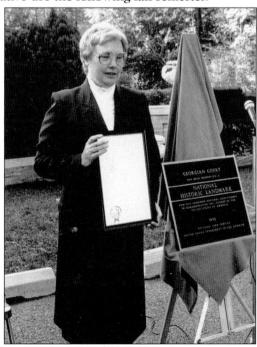

In 1985, the campus was officially named a national historic landmark, a declaration that would help secure funding to maintain and revitalize the beauty of many original Gould buildings, statues, and fountains in the coming years. Here Sister Barbara Williams '63, Georgian Court College president, stands with the declaration and plaque, which now resides in the rose garden near the Seventh Street Gate.

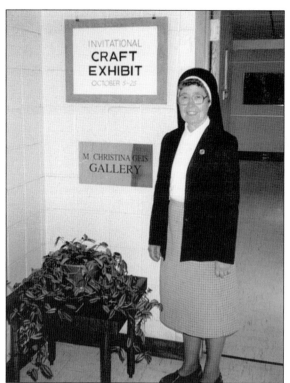

Sister Mary Christina Geis '49 stands with the plaque that bears her name at the 1985 dedication of the M. Christina Geis Art Gallery. Sister Christina was a professor of art at the Court for over 40 years and is well known for her impressive watercolors. She was awarded the title professor emerita upon her retirement in 2001.

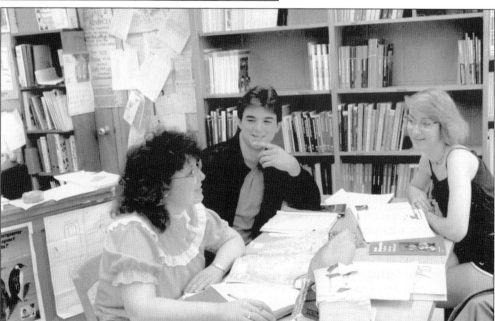

Three future educators work on lesson plans in the Instructional Media Center (IMC) in this 1986 catalog photograph. The IMC, housed in the Arts and Science Center, was a busy spot for education students completing assignments and preparing for student teaching experiences. The IMC was later moved to the Sister Mary Joseph Cunningham Library, where it remains today.

# Five

# BE GOOD TODAY, BUT BETTER TOMORROW
## 1987–1999

*My legacy to the Institute is charity. If you preserve the peace and union . . . you will feel, even in this world, a happiness that will surprise you, and be to you a foretaste of the bliss prepared for every one of you in heaven.*

—Catherine McAuley

Sister Barbara Williams '63, seventh president of Georgian Court, knew that the college had come a long way since she arrived as student Sister Mary Francis Xavier. As faculty, staff, administrator, and president, Sister Barbara focused on the initiation of planning, human resources, and mission. It was a time of turmoil for the country, with the Iran-Contra scandal and numerous other presidential scandals. But it was also a time of great progress for women. Sally Ride, the first American woman in space, orbited Earth; Sandra Day O'Connor took the oath of office as the first female Supreme Court justice; and Geraldine Ferraro accepted the nomination for vice president of the United States. Through all of this social change, the college never lost sight of its Mercy roots. Its special concern for women included ministry to the poor through cafeteria food supplies and campus ministry social programs.

During these years, college enrollment doubled and master's degree programs were added in biology, business administration, counseling psychology, mathematics, education with teaching certification, instructional technology, and theology. Undergraduate degrees in fine arts and social work were initiated. The Departments of Business Administration and Social Work received accreditation from their respective associations. Construction and renovation was begun and completed for a new library, a student lounge, a center for psychology and business administration, and a center to house a college bookstore and Department of History offices. A $2 million restoration of the Casino was begun. In addition, the Sister Mary Grace Burns Arboretum was dedicated, and NASA chose Georgian Court to serve as the New Jersey Regional Teacher Resource Center. Satellite dishes were installed, a campus-wide computer network was introduced, and the first distance learning course was offered.

Just as the century turned, the Ocean County Chamber of Commerce chose Georgian Court College as Educational Organization of the Year, and the college was clearing the path to a "better tomorrow."

Georgian Court College athletic teams moved from the New Jersey Association of Intercollegiate Athletics for Women (NJAIAW) into the National Association of Intercollegiate Athletics (NAIA) in 1980. One popular sport, karate, was discontinued in the late 1980s after almost a decade of competition in the International Shotokan Karate Federation. Soccer was added as an intercollegiate sport in 1989 and continues to be played at Georgian Court today, as do cross-country, basketball, and softball. The athletic teams participate in many regional conferences and championships. Even more important, athletes maintain high grade point averages and are leaders in their major academic fields.

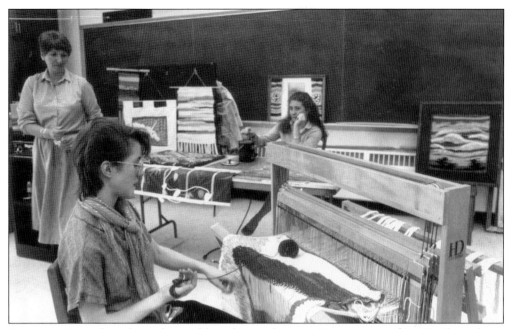

Georgian Court has always been able to boast about its Department of Art. Both students and professors turn out unusual artistic displays in all media. In this picture, Laura Rutherford '85 and Laura Hunt '85 prepare hangings under the watchful eyes of Geraldine Velasquez, Ed.D., professor of art.

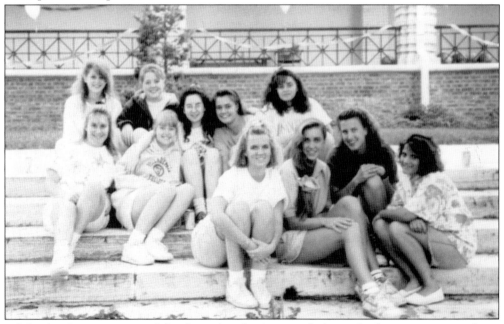

While the Casino was used for formal gatherings and physical education, it was also a place for fun and good times. At a moment's notice on Thursday and Friday evenings, lights, balloons, and music made for an evening of fun and dancing at a back porch party to celebrate good times. There was never a shortage of eager students to set up the event.

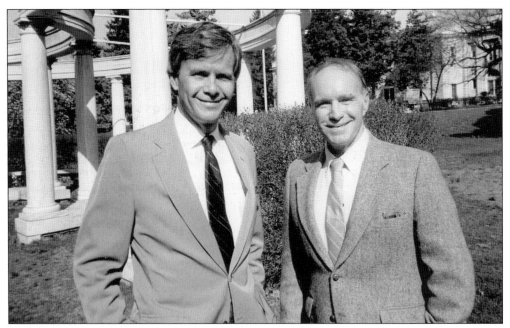

Based on a recommendation from the New Jersey Department of Education, Tom Brokaw of NBC's *Nightly News* chose Georgian Court College to be featured in his documentary, *To Be a Teacher*. After receiving the go-ahead from Jim Williams, chair of the Department of Graduate Education, four Georgian Court student teachers were followed by cameramen documenting their first to last days of teaching and class preparation.

On the recommendation of the New Jersey Council of the Arts, the popular Pennsylvania department store Strawbridge and Clothier chose the campus as the setting for its 1988 holiday catalog photographs. Photography was completed during the summer. Favorite spots included the Apollo Fountain and the Lagoon, which made superb backdrops for the featured holiday wear. The beauty of Georgian Court enhanced and highlighted the fashions of the day.

Ocean County has been one of the fastest-growing counties in New Jersey with miles of pine barrens, barrier islands, and coastline. Its elections have always been fought hard and won with difficulty. Seen here are Democrats Bill Bradley, a U.S. senator from New Jersey (right), and John Paul Doyle, a New Jersey assemblyman.

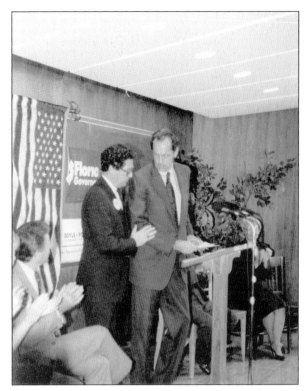

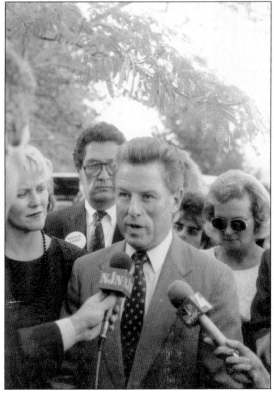

Candidates running for election make many stops in the area. Loyal Georgian Court alumni have always been influential in introducing the candidates to the campus and introducing the campus to the candidates. James Florio, then Democratic candidate for governor of New Jersey, seen at left, is interviewed by New Jersey Network News on the college campus.

The Sister Mary Grace Burns Arboretum, which includes the campus's four historic gardens, was dedicated on April 23, 1989, and holds membership in the American Public Gardens Association. The mission of the arboretum is to preserve and enhance the botanical history of the former estate and its gardens. Each year new plants or trees are added, some of which are dedicated for specific persons or events.

Sister Mary Grace Burns, Ph.D., '23 taught biology for 41 years. She not only instructed her students about trees, plants, and shrubs, but cared for the plants and flowers herself by raking leaves, watering plants, and trimming bushes. She would have relished the annual Arboretum Day celebration, which includes the music, poetry, dances, and art of faculty and students.

Many honors were bestowed on the science departments in an era when women were just beginning to be recognized for scientific undertakings. Two Georgian Court College senior biology majors, Jean Smith '94 (left) and Jean M. Fede '94, pursued laboratory studies at Catholic University in Washington, D.C. They were chosen along with 26 other college students to receive full scholarships, room, and board for a weeklong science seminar at the university.

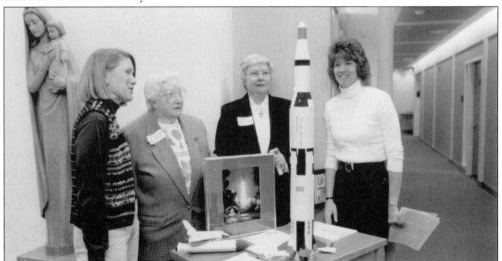

NASA summer workshops for teachers were hosted and directed by Sister Mary Nicholas Farley '47, professor of physics. Teachers of middle and junior high schools were able to update and enrich their science programs, covering such areas as aeronautics, rocketry, astronomy, and living in space. NASA also paid for teacher and college expenses and provided for a section of the library dedicated to science teachers who wanted to update their classroom curricula.

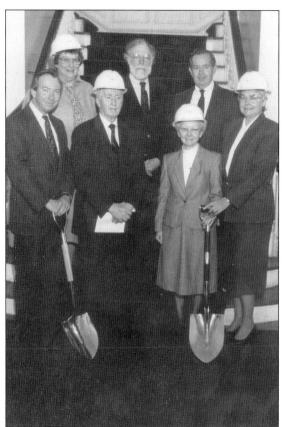

The year 1991 saw the groundbreaking for a new library and student lounge complex. On the steps of Kingscote are the people responsible for initiating the planning and building of the modern, spacious, and technologically enhanced building. Pictured are, from left to right, (first row) James Brecker, contractor; Ed Connelly, college attorney; Sister M. Theresina Flannery '57, board chair; Sister Barbara Williams '63, Georgian Court College president; (second row) Barbara Hutchinson, director of library services; Bill Dix, architect; and Ed Pillion, plant manager. When the new library opened in 1993, the modern facility contained study carrels, movable bookshelves, a computer laboratory, and an area where one could read, plan work, or discuss a project. Students could pull their own journals, microfilm, and microfiche and look up books on a computerized card catalog without having to fill out request forms in duplicate.

Financial officer, assistant to the treasurer, treasurer, and vice president for administrative services were titles held by Sister Mary Joseph Cunningham '53. But none suited her more than Religious Sister of Mercy. Upon her death, it was decided that in honor of all that she had done for Georgian Court and its students, the library would be named in her honor.

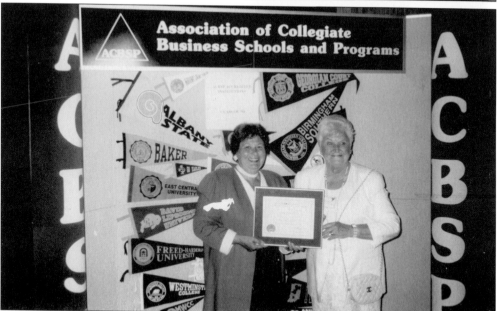

As academic programs, business and economics were in and out of the curricula, having been offered in 1940, dropped in 1966, and reinstated in 1978. This photograph records a gratifying achievement: accreditation of the entire Department of Business Administration, Accounting, and Economics by the Association of Collegiate Business Schools and Programs. Holding the certificate of achievement are Binetta Dolan, chair of the Department of Business (left), and Anne Fosbre, Ph.D., professor of accounting.

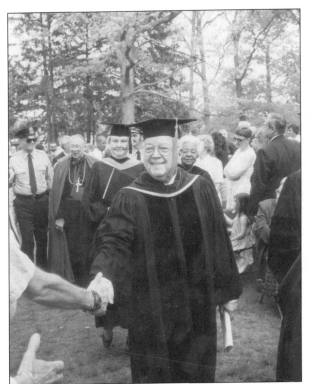

H. George Buckwald, a local philanthropist and community leader, receives an honorary degree. Buckwald served as executive director of the Lakewood Industrial Commission and was the founder of the Lakewood Industrial Park. As proud as he was of his World War II Purple Heart and local activities, he was delighted to receive an honorary degree from Georgian Court and enjoyed being addressed as Dr. H. George Buckwald, Georgian Court College class of 1996.

Commencement at Georgian Court is always a time of bittersweet celebration—graduates are excited about what lies ahead but sad to see their college years end and reluctant to leave friends and faculty behind. These young graduates seem ready to explore the world outside the Seventh Street Gate on which they are posed. At least they are ready for a running start in their sneakers!

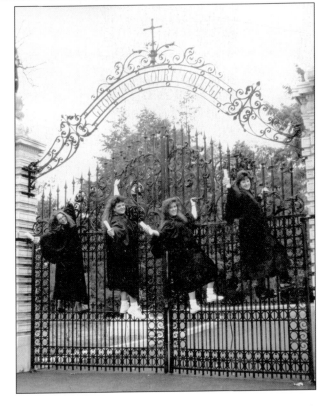

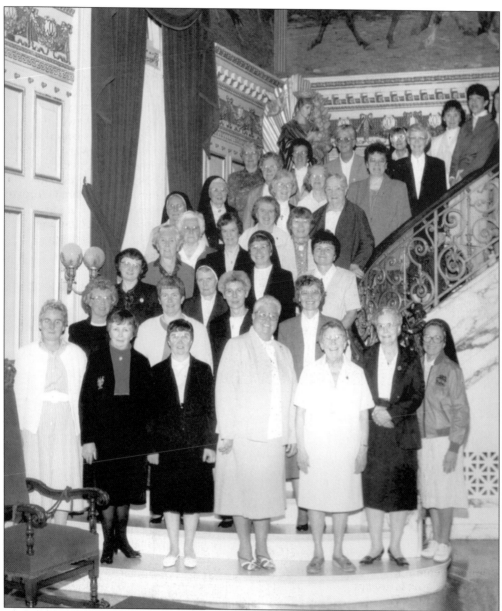

The Sisters of Mercy serving at Georgian Court College in 1993 stand on the staircase in the great hall of the Mansion. Pictured here are Jeanine Oliver '70, Mary-Theresa McCarthy '57, Miriam Golden '70, Francesca Holly '69, Mary Joan Brady '31, Mary Sheila Storm '36, Gemma Jannucci '56, Marie Bernadette Pape '69, Cecelia Fox '76, Mary Gail Nolan '69, Katherine Mroz, Marie Cook '64, Mary Madeline McCarthy '52, Marilyn Grimley, Mary Phyllis Breimayer '63, Judith Schubert '66, Margaret Mary Foley '48, Margaret Dalton '47, Mary Peter Coakley '47, Carol Creamer '69, Mary Olga Felsmann '46, Mary deSecours McIntosh '54, Barbara Williams '63, Mary Valerie Balbach '56, Ellen McBride '69, Mary Stephanie Sloyan '39, Mary Nicholas Farley '47, Joyce Jacobs '67, Dorothy Lazarick '67, Edwina Rudolph '66, Mary Joseph Cunningham '53, Mary Catharine Sullivan '55, Mary Franey '58, visitor Cindy Scalese, and Mary Shaun Franey '56.

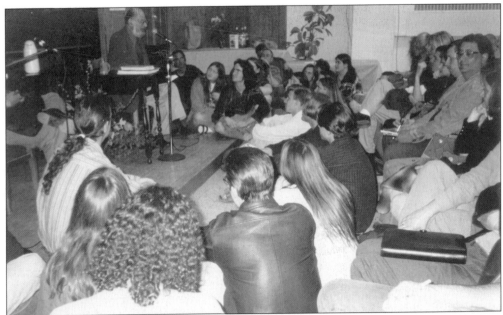

Through his poems, poet and guest lecturer Allen Ginsberg gave English majors and others a lot to think about in his 1995 visit. Ginsberg wrote about his love of personal freedom, his fellow members of the beat generation, and his rebellion against conformity. He protested against the war in Vietnam, and for gay rights and free speech. His most famous poem, *Howl*, was a long, sad poem about materialism and conformity in the United States.

Walter Persegati, retired secretary general and treasurer of the Vatican monuments, museums, and art galleries, is pictured here on his visit as a lecturer at Georgian Court in 1997. Persegati directed the controversial renovation of the Sistine Chapel ceiling and frescoes. As he toured the Georgian Court campus, Persegati recognized the beautiful design and architecture of the estate as copies of European originals.

Sister Mary Joseph Cunningham '53, college treasurer, cuts the ribbon at a ceremony for the first Georgian Court multimedia computer laboratory, donated by AT&T. Excited members of Georgian Court faculty and administration and AT&T representatives look on.

Neil Belles, director of information technology (right), and Jay Zahner, faculty/staff computer support specialist (center), watch as Jo-Ann Greenhalgh, instructional technologist, explains a new means of communication. Videoconferencing gave faculty and students a new way of being present at convention sites. They could see and hear what was being said in real time, as well as telephone in questions and receive immediate responses.

Helen Boehm, widow of artist Edward Marshall Boehm, designed two roses for Georgian Court. The first (shown here) was a pink American beauty rose in a silver bud vase aptly titled the Georgian Court Rose and was created for the college's 75th anniversary. The second, the Georgian Court College American Peace Rose, honored the 90th anniversary in 1998. Boehm porcelain can be found in the Vatican, the Smithsonian, and other museums.

Each year since 1998, Georgian Court has hosted a society fund-raiser known as the gala. Guests enjoy candlelight, gourmet fare, and dancing to raise money for the college. Pictured are Diane Turton, president, owner, and broker of record of Diane Turton Realtors (left); and Helen Boehm, chair of Boehm Porcelain Studios.

Over the years the stucco and redbrick wall around Kingscote (above) began to crumble. The wall was the portal through which students returned home to their dormitory rooms and through which administrators approached their desk duties. But by the late 1990s, it showed its age. The wall and archway were demolished in 1998 and were replaced with new fencing. With the open ironwork fence, Kingscote came into prominent view to passersby. As seen in a modern photograph, the view is breathtaking in all seasons but especially in the spring, when pink and white dogwood, yellow forsythia, and magenta rhododendron display their colors.

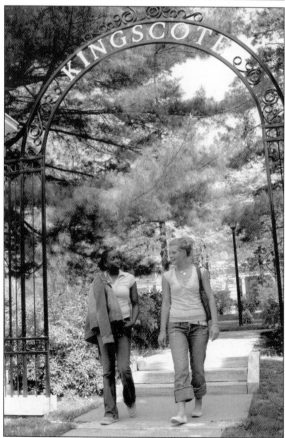

At a gathering of Catholic college representatives for a discussion of Catholic identity and values are (from left to right) Joseph Springer, Ph.D., assistant professor of psychology; and Sisters Patricia Geary, GNSH, Ph.D., professor of education; Edwarda Barry, Ph.D., '59, director of mission integration; Marie Cook, Ph.D., '64, professor of biology and dean of academics; Virginia Hasson, Ph.D., professor of education; and Mary Arthur Beal, Ph.D., '55, dean of the Graduate School.

Georgian Court honored Sister Mary Arthur Beal on the occasion of her retirement as dean of the Graduate School in 1999. Pictured with Sister Mary Arthur, from left to right, are Rev. Edward G. Reading, lecturer in education; James E. "Barry" Ward, lecturer in education; and Benedict Trigani, Ph.D., professor of education. Today Georgian Court offers graduate degrees in administration and leadership, biology, mathematics, counseling psychology, business, education, theology, instructional technology, and holistic health.

Bishop John M. Smith, J.C.D., D.D., newly appointed to the Diocese of Trenton in 1997, makes his first visit to the only four-year Catholic college in his diocese. Traditionally the bishop is present for groundbreakings and graduations. Sister Barbara Williams '63, Georgian Court College president (center), and Sister Mary Arthur Beal, Ph.D., '55, dean of the Graduate School (right), greet and welcome Bishop Smith in the Mansion and introduce him to faculty and staff.

Playing to capacity Casino audiences is Fr. Alphonse Stephenson and his renowned Orchestra of St. Peter by the Sea. Since 1999, his annual Christmas at the Court concert of Advent and Christmas music has added an artistic dimension to the holiday season. Father Alphonse is well known as the conductor of Broadway's *A Chorus Line*.

Shown here with Mary Smith, secretary Dorothy Horner (left) celebrates 35 years of service to six deans of student services—Sisters Mary Placidus Geary '24, Mary Nicholas Farley '47, Mary Catharine Sullivan '55, Mary Lucia Chiurato '45, Carolyn Martin '68, and Edwina Rudolph '66. Originally entitled Dean of Women, the title was eventually changed to Dean of Student Services to include the entire coed student population.

Students always hold memories of their dining hall experiences—and their favorite and not-so-favorite dishes. Always on hand, members of the kitchen staff cook, wash, clean, and set up for at least 16 hours a day. On snowy days, cots were sometimes set up in the dining hall so that staff would be available to serve breakfast. These wonderful employees served many years and even knew students' favorite meals and desserts.

# Six

# The Dawning of
# a New Century
## 2000–2007

*We can never say it is enough . . . we ought every day to consider
we are commencing anew our advancement in perfection.*

—Catherine McAuley

A new era, emanating from a fresh vision statement, dawned at Georgian Court in the early 21st century with the prospect of the college becoming a university. In February 2004, this dream became a reality as Georgian Court officially became the 16th comprehensive university and the second Catholic university in New Jersey.

The Georgian Court University perspective is unique in New Jersey's higher education landscape. Founded on the Mercy core values of respect, compassion, service, integrity, and justice, and embedded with a special concern for women, Georgian Court is moving quickly to make its mark as an esteemed university. More than $28 million in the construction and renovation of five campus buildings took place during these years.

A comprehensive $10 million Campaign for Georgian Court was launched on June 17, 2004, and is exceeding its fund-raising goal. This campaign will guarantee continued excellence in women's education with a strong women's leadership component.

With university status came a focus on reenergizing academic life through the appointment of a Presidential Commission on the Academic and Student Life Master Plan. The goal was to strengthen the university's tradition as a Catholic liberal arts institution and to reinforce its mission and Mercy core values. The results were a new core curriculum, redefined graduation requirements, seamless transfer policies with community colleges, and a requirement for undergraduates to have service learning experience and a global perspective.

Georgian Court entered into partnerships with other colleges to provide innovative educational ventures for traditional and nontraditional students. Georgian Court is the only private higher education partner in New Jersey Coastal Communiversity. Articulation agreements with six community colleges paved the way to launching Georgian Court satellite sites in Middlesex and Cumberland Counties.

In 2003, a new community outreach effort called the McAuley Learning Institute was launched. Through the institute, educational, spiritual, and cultural events are shared with the surrounding community through lectures, concerts, and theatrical performances, historic recreations for kindergarten through grade 12 schoolchildren, tours, and travel. The institute, now named the McAuley Community Center, brings an average of 23,000 visitors to campus annually.

Sister Rosemary E. Jeffries, Ph.D., '72 became the eighth president of Georgian Court on July 1, 2001. Sister Rosemary brought with her an understanding of higher education and both secular and religious leadership experiences and has led the university through unprecedented growth since she took the helm. Under her leadership, the Campaign for Georgian Court and a successful development effort was launched. The number of scholarships and endowments that enable more students than ever to attend the Court has increased, and innovative academic programming is preparing students to thrive in an ever-changing, global society. Improvements to facilities and infrastructure are ensuring that the university and its students keep pace in a technology-driven world. At the heart of this progress is the new Wellness Center for which ground was broken in the spring of 2007.

In a gardenlike setting in front of the Arts and Science Center is the Georgian Court University Peace Pole. Installed during Inauguration Week 2001, the six-sided pole displays the prayer, "May peace prevail on Earth," in 12 different languages. Members of the campus community gather frequently around the pole for sharing and prayer in times of personal, national, or global need or strife.

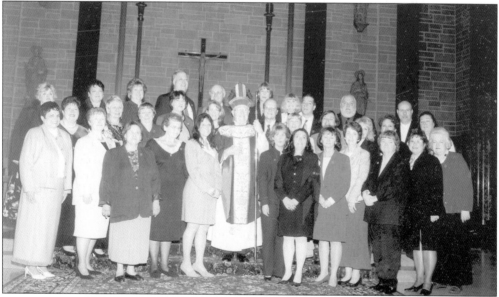

In 2001, Georgian Court University entered into a collaborative venture with the Institute for Lay Ecclesial Ministers, sponsored by the Diocese of Trenton. The university provides the academic component of that program, which includes spiritual formation and pastoral skills development. The first class of men and women pictured here were commissioned as lay ministers on December 12, 2004, by Bishop John M. Smith, J.C.D., D.D.

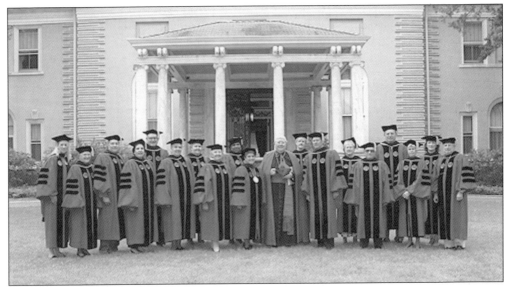

Georgian Court University became New Jersey's 16th comprehensive university and the second Catholic university in the state on February 27, 2004, when the New Jersey Commission on Higher Education approved its application. Above, the board of trustees, wearing new academic regalia, proudly award the first diplomas to proclaim "Georgian Court University" at the 2004 commencement ceremonies. Below, Sister Rosemary E. Jeffries, Ph.D., '72, university president (center), celebrates Georgian Court's achievement with members of the Court administration, faculty, and board of trustees. To celebrate its well-deserved status as a university, Georgian Court designated the week of September 23, 2004, as University Week. Among the events held during the celebration that week were an especially poignant Mercy Day featuring the ribbon-cutting on a new student residence hall, the long-standing Family Day, the Court Classic 5K Run, and Alternative Learning Day.

Jubilant students celebrate the new campus signage that greets visitors to the campus and declares Georgian Court's university status.

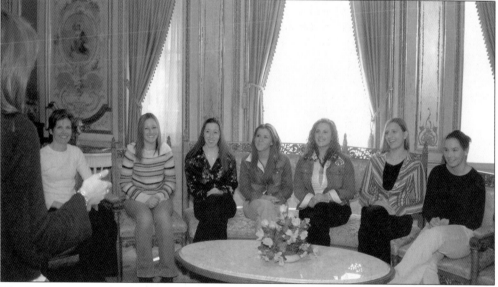

The Women in Leadership Development (WILD) program was established in 2003. This intensive, four-year journey helps students develop the skills and tools that successful women leaders possess. The WILD experience includes lobbying at the state level, serving on major university committees, attending leadership conferences and intensive weekend retreats, teleconferencing with prominent women leaders, professional networking, and mentoring first-year WILD participants.

With university status came a new multimedia branding and image campaign creating all-new recruitment materials; university marketing pieces covering print, television, radio, and billboards; and a brand-new university Web site. A new logo and tagline positioned Georgian Court to be competitive in New Jersey's higher education marketplace. Focusing on tradition, opportunity, and transformation—the campaign uses the tagline "A Tradition of Excellence . . . A Future of Success." The marketing campaign increased public awareness about the mission of Georgian Court University, which, as the Mercy University of New Jersey, continues to focus on the education of women and women's leadership in the Women's College and on expanding opportunities for busy working men and women in the coeducational University College. Every component of the new image and marketing campaign won marketing and communications awards from regional, statewide, national, and international competitions.

In November 2003 Georgian Court University at Woodbridge opened its doors to offer busy working adults accelerated and affordable educational opportunities to enhance or change their careers. Conveniently located near all the major New Jersey roadways, Georgian Court University at Woodbridge offers degree-completion programs in business and education at both the graduate and undergraduate levels.

In February 2003 Georgian Court inducted its first group of alumnae into the Athletic Hall of Fame. Pictured standing are (from left to right) Carol Walters '91, New Jersey's second-highest female scorer (basketball), and Carolyn "Nickie" Kelly '97 (soccer). Pictured in the first row are (from left to right) Gail Scardillo Caverly '85 (basketball), Robyn Saul Magovern '80, '92 (volleyball, basketball), and Stacey Ryan Weinert '94 (basketball, soccer).

The School of Sciences and Mathematics encourages students to follow their passion and break new ground in the natural sciences, social sciences, mathematics, and social work. The state-of-the-art Audrey Birish George Science Center, opened in the fall of 2005, is an exciting place for students to explore the latest research findings, use the scientific instrumentation, join in the research of their professors, and even develop their own research projects.

The School of Education has a legendary reputation for educating teachers in New Jersey. For several years, 100 percent of Georgian Court teacher education candidates have passed the state Praxis II certification exam. In 2004, the School of Education upheld its leadership role for teacher preparation by receiving state approval for reconfiguration of all 20 instructional programs to meet new state teacher education licensure codes.

The School of Arts and Humanities encourages students to explore the human experience as it is expressed globally through religion, philosophy, history, literature, art, and music. Grounded in creative and professional, discipline-specific and interdisciplinary courses, students are immersed in leadership development, research, professional presentations, internships, and service learning.

The School of Business prepares students for today's complex, global, and rapidly evolving business world. The fully accredited school offers an outstanding curriculum enhanced by advanced technology and taught by accomplished and experienced professors. From the undergraduate and master of business administration levels to accelerated and certificate programs, the School of Business provides students with the knowledge to succeed and the leadership skills to excel.

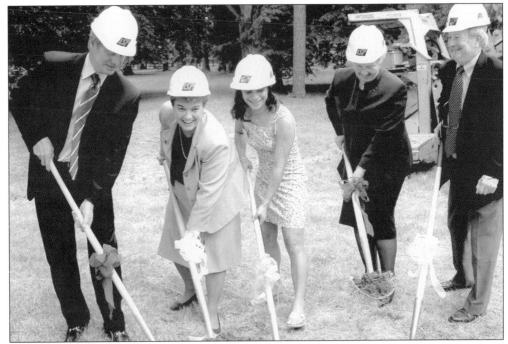

Breaking ground on May 30, 2003, for a new residence hall and chapel complex was a five-spade project. Pictured are (from left to right) Brian Buckelew, chair of the board of trustees; Rosemary Jeffries, Ph.D., '72, Georgian Court president; Yanci Pereira '04, president of the Student Government Association; Diane Szubrowski '68, president of the Sisters of Mercy of the Regional Community of New Jersey; and Edmund Bennett, member of the board of trustees.

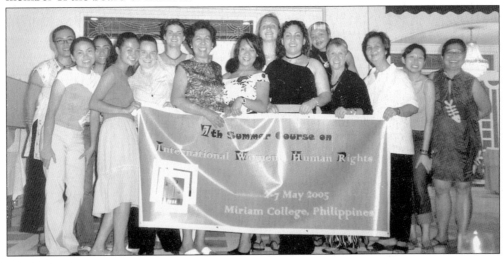

The Office of International Programs was established in 2004. Pictured here are Georgian Court University students experiencing a bit of culture in Manila. As guests of Miriam College in the Philippines, the university delegation participated in the Seventh Summer Course in International Women's Human Rights. To advance the university's international/global strategic initiative, faculty members accompanied students on university-sponsored short-term trips to Quebec, Vietnam, Spain, and the Philippines.

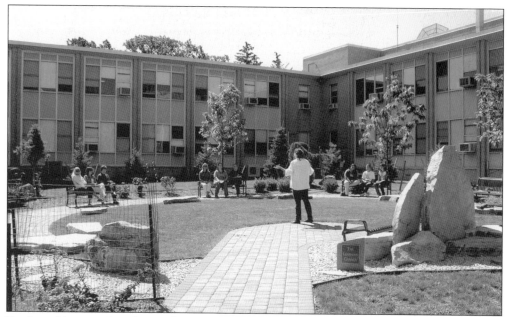

Designed by a national award-winning architect and completed in 2006, the Discovery Garden integrates a variety of disciplines, including physics, biology, chemistry, mathematics, art, psychology, and holistic health. Funded by a grant and donations, the garden incorporates an outdoor classroom and sculpture garden. Plantings are drought resistant and either New Jersey native plants or noninvasive plantings.

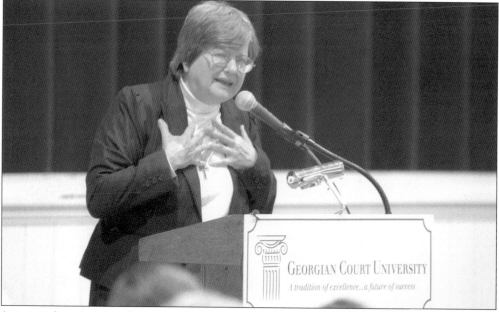

Sister Helen Prejean, CSJ, visited the university in March 2006 as a participant in the Women of Witness series. Her message of opposition to the death penalty invited the audience to consider the death penalty in terms of the values of compassion, respect, and justice. Her conviction in this regard is expressed in her 1993 Pulitzer Prize–nominated book *Dead Man Walking* and a film of the same title.

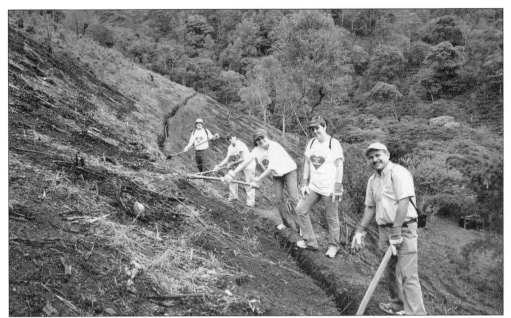

Georgian Court participates in programs that make a difference. As a compassionate service project, the university sends a contingent of students and staff to Honduras each spring. There students have assisted in building water systems, building a new school in San Manuel, and bringing clothing and other necessities to village schoolchildren.

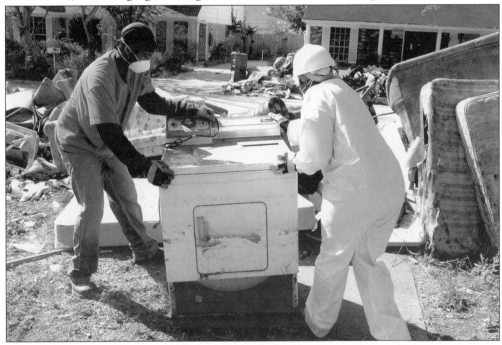

In the spirit of mercy, a team of Court students and staff traveled to Hurricane Katrina–devastated New Orleans in the spring of 2006 to spend a week restoring the badly battered homes of the elderly and disabled. In just six days, they rebuilt two homes and started work on a third.

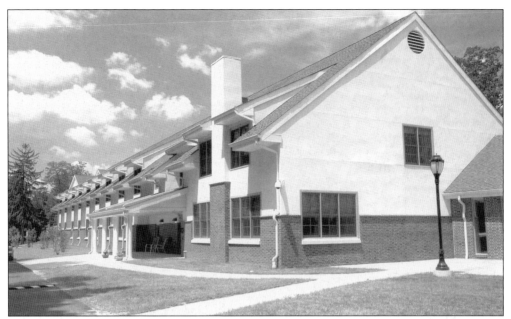

In 2004, Mercy Hall welcomed the Sisters of Mercy who serve Georgian Court. Never before had the women religious community had the welcome opportunity to live together in a campus residence. Mercy Hall contains single living units with several lounges, visitation rooms, and laundry facilities as well as a central kitchen and dining area. Also included are two apartments for use by visiting faculty accessible through private entrances. Each of those apartments includes a kitchen and living and sleeping quarters. Mercy Hall is one of three new cream-colored buildings situated along Lake Carasaljo that offer spectacular lake views.

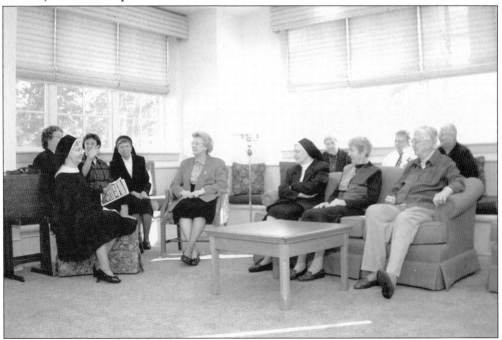

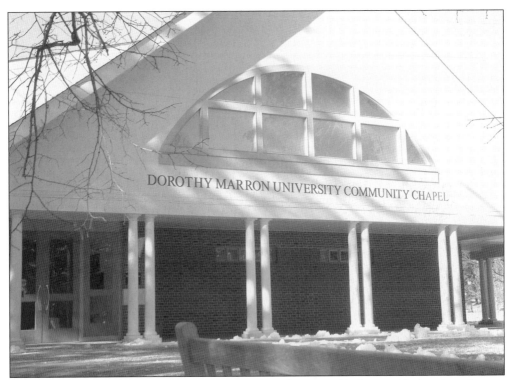

The Dorothy Marron University Community Chapel is named in honor of generous alumna Dorothy J. Marron '36. Opened on January 25 and dedicated on April 19, 2005, the new chapel, with its soaring open design, has been developed as a large gathering space for worship, campus meetings, and other group functions. With seating for 150 persons, the 5,660-square-foot chapel serves as a center to enhance the spiritual environment on campus. The building was chosen to appear in the 2005 *American School & University* education interiors showcase issue. The competition honors educational interior design excellence, and the chapel was selected as an outstanding project in the chapels/worship centers category.

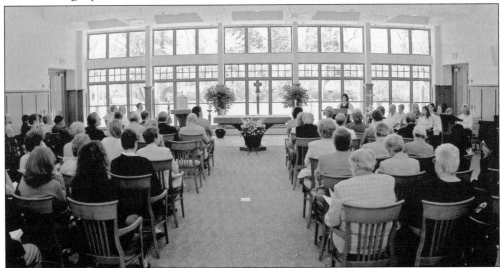

St. Catherine Hall is Georgian Court University's newest student residence. The three-story, 38,000-square-foot building accommodates students in two-bedroom suites and single units. It features the latest in on-campus living with high-speed cable internet access, cable television, full generator backup, a computer lab, and electronic card access—a safe alternative to keyed access.

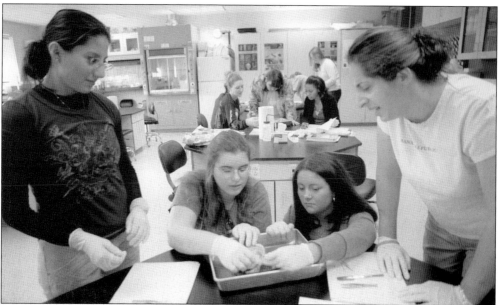

New and remodeled spaces on the university campus are enhancing the learning environment at every turn. The state-of-the-art Audrey Birish George Science Center added 14,000 square feet of fully equipped teaching laboratories with plenty of space for adequate preparation and storage and faculty and student research. The wing also features the ultramodern 40-seat interactive media classroom, the OceanFirst Multimedia Theater.

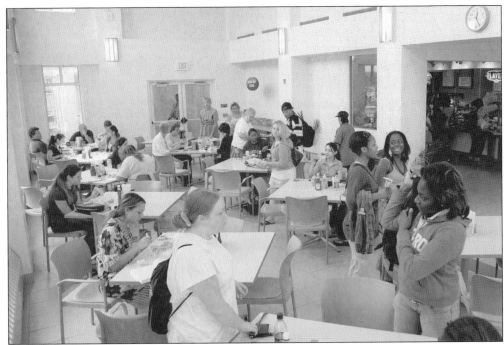

The redesigned and expanded Court Café is an inviting, centrally located place for eating, taking a break, studying, and gathering with friends. The new design is bright and open with seating both inside and outdoors on a brick patio with umbrellaed tables.

In 2006, Georgian Court awarded the first Alumni Lifetime Achievement Award to Gertrude Turner Mahon '35. The award honored her 70 years of service and commitment in fostering the connection between alumni and Georgian Court. Pictured here are a beaming Gertrude (left) and a grateful Beverly Milyo '69, '83, president of the alumni association (right).

The Lions compete in seven NCAA Division II and Central Atlantic Collegiate Conference (CACC) sports: basketball, cross-country, lacrosse, soccer, softball, tennis, and volleyball. They have one of the longest-running women's basketball programs in the CACC, with three CACC championships and four CACC runner-up awards. The cross-country team has been NCAA conference champions five out of the past seven years. The soccer team has won eight CACC tournament championships. The softball team has won eight CACC championships. The 2004–2005 team placed 14th in the nation and 1st in the Northeast for NCAA Division II softball teams for their GPA. The tennis team advanced to the inaugural CACC championship in 2005 and placed seven athletes in individual singles and doubles in the CACC 2005 championship. The volleyball team captured its first CACC championship in 2006 and advanced to the NCAA Division II regional tournament for the first time.

Dreams Create Futures
Campaign for Georgian Court

GEORGIAN COURT UNIVERSITY

LAKEWOOD, NEW JERSEY

In April 2006 distinguished donors, friends, and students of the university gathered to cheer on the public launch of the Campaign for Georgian Court. One of the most ambitious fund-raising initiatives in the university's history, the campaign announced a goal of $10 million. By the end of 2006, $10.8 million had already been raised to build a bright future for university students.

The cornerstone of the Campaign for Georgian Court is the new Wellness Center, which will provide the Georgian Court community with a modern, centralized space for the interaction of body, mind, and spirit. The Wellness Center will be "green," using energy-efficient systems and recycled materials. Plans also call for the construction of an arena, athletic fields, updated tennis courts, a professional track, dance studios, exercise facilities, and a university bookstore.

124

Georgian Court University initiated a student laptop program in the 2005–2006 academic year to better integrate technology into student learning and teaching. Laptop computers were distributed to all first-time, full-time freshmen. SMART technology systems in classrooms are a common sight in 2007, including the university's first rooms with Sympodiums.

The great hall of the Mansion is the setting for the *Biographies from the Court* series. Launched in 2003, the theatrical series portrays Edith Gould, wife of George Jay Gould, former owner of the Gould estate, hosting celebrities of her time. "Edith" is shown here with an actor portraying baritone Enrico Caruso. Conversation is based on actual events in the lives of the celebrity guests and on anecdotes recorded in the Gould family history.

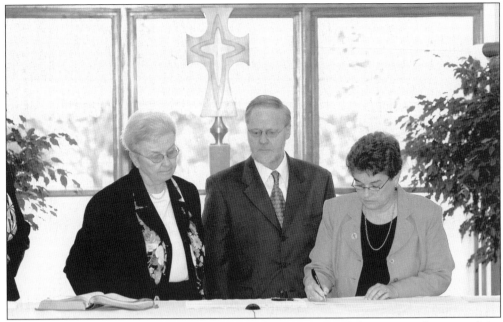

On April 30, 2006, Sister Diane Szubrowski '68, president of the Sisters of Mercy of the Regional Community of New Jersey, transferred the sponsorship of Georgian Court University to the Conference for Mercy Higher Education. The conference coordinates collaboration among the 18 Mercy colleges and universities throughout the country on behalf of the Institute of the Sisters of Mercy of the Americas. Accompanying Sister Diane are Sister Rosemary Jeffries, Ph.D., '72, university president, and Joseph Gower, Ph.D., university provost.

Board of trustee leaders, from left to right, Edmund Bennett Jr.; Patricia E. Koch, Esq., '69; the first lay alumni chair of the board, and Raymond F. Shea Jr., Esq., vice chair, discuss exciting plans to transform the McAuley Heritage Chapel into a central gathering spot on the campus for celebrating the Sisters of Mercy heritage and the century of academic service provided by Georgian Court.

126

A redesigned Raymond Hall courtyard features a special bronze bust of Catherine McAuley as the central focus. It quickly became a favorite meeting spot for students. The bronze likeness of the founder of the Sisters of Mercy was created by Sister Marie Henderson, a sculptor from Detroit, and donated to the university by Mary Enyart '74.

ACROSS AMERICA, PEOPLE ARE DISCOVERING
SOMETHING WONDERFUL. *THEIR HERITAGE.*

Arcadia Publishing is the leading local history publisher in the United States. With more than 3,000 titles in print and hundreds of new titles released every year, Arcadia has extensive specialized experience chronicling the history of communities and celebrating America's hidden stories, bringing to life the people, places, and events from the past. To discover the history of other communities across the nation, please visit:

# www.arcadiapublishing.com

Customized search tools allow you to find regional history books about the town where you grew up, the cities where your friends and family live, the town where your parents met, or even that retirement spot you've been dreaming about.